12.50

Richard Shone

MANET

With 40 color plates

PARK SOUTH BOOKS
An imprint of
Publishers Marketing Enterprises Inc.
386 Park Avenue South
New York, New York 10016

Published by PARK SOUTH BOOKS
An imprint of Publishers Marketing Enterprises Inc.
386 Park Avenue South
New York, New York 10016

First published in the U.K. by
Thames and Hudson Ltd, London

© John Calmann and Cooper Ltd, 1978
This book was designed and produced by
John Calmann and Cooper Ltd, London

Reprinted 1985

Library of Congress Catalog Card Number: 84–61598

ISBN 0–917923–03–0

Printed in Hong Kong by Mandarin Offset Ltd

Introduction

OF MANET'S *Olympia* (*plate 8*) the young Cézanne remarked: 'We must keep that in sight. It's a new step in painting. Our Renaissance begins there; it's a real painting of things. Those pinks and whites lead us along a path our sensibilities knew nothing of before.' Manet has for long been regarded as a pivotal figure in nineteenth-century art, a vital influence on his own generation who challenged the very constitution of painting itself. To examine Manet's painting – that complicated synthesis of past and present with its implications of the future beneath lucid and charming surfaces – is to come face to face with many of the preoccupations of artists since his time. Several of his paintings have burned themselves into the whole tradition of inherited visual imagery: *Olympia* and *Luncheon on the Grass* frequent our daily lives.

Yet his work still causes disagreement and is constantly being revalued. He seems to be both a traditionalist and a remarkable innovator; a compound of romantic and realist capable of working in a variety of styles; a revolutionary from within the Parisian bourgeoisie hankering after official recognition. He was a close associate of the Impressionists and shared some of their aims but it becomes increasingly apparent that he was an artist of a different kind. In spite of the strength of his images, he stands at the beginning of the movement that saw the gradual diminishing of the importance of subject-matter which culminated in the art of this century. He opposed the picturing of the world through an ideal or moral filter, by concentrating on the object. This was the point of Cézanne's remarks – the object was rescued from preconceptions, no longer limited by non-pictorial impulses, and was at the root of his preservation of a singular purity of vision. He is neither picturesque nor rhetorical; he has little of the social or symbolic atmosphere of Courbet; ambrosial landscapes and moral homilies play no part in his imagination. Divesting his subjects of so many of those attributes thought necessary to successful painting, he was inevitably accused of banality, of being interested only in technique, of 'saying' nothing. Olympia's unequivocal station in the Paris of the Second Empire and the directness with which she and her world are evoked drew moral censure through the painter's deliberate lack of comment; similar passions were aroused by the undisguised contemporaneity of the *Luncheon on the Grass* (*plate 3*); his *Dead Christ with Angels* (*plate 9*) was thought sacrilegious because it depicted, in Emile Zola's words, 'a corpse painted in full daylight with freedom and vigour'. It would be a mistake, however, to see in Manet a painter cold and impersonal, too elegantly detached (the Baudelairean dandy) to register his emotional responses. His quality of silence, of being submerged in the realization of what is in front of him, was at the time radically personal; he responded to a large variety of subjects; his emotional reactions range from an unemphasized melancholy (*The Fifer*, *plate 13*; *The Balcony*, *plate 18*) to a warm and sensual intimacy (*Argenteuil*, *plate 29*; *At Père Lathuille's*, *plate 34*); from a trenchant delight in the urban scene (*At the Café*, *plate 35*) to an amused contemplation of arresting personalities. While his colour harmonies tend to be cool and restrained, they are instantly recognizable – certain combinations of white and ivory,

a whole gamut of greys, dusty pinks and black, with here and there vibrant touches of light red, lemon yellow, ochre and grey-blues (the foreground picnic in *Luncheon on the Grass*, the flowers and Indian shawl in *Olympia*). His work reveals a pungent temperament in which many of the seeming contradictions and complexities of his character have been resolved.

Manet was born on 23 January 1832 in Paris. His father Auguste worked for the Ministry of Justice, his mother was a diplomat's daughter. He had two younger brothers, Eugène and Gustave, the former marrying the painter Berthe Morisot (*plates 18, 20*) in 1874. He was educated at the Collège Rollin and already wanted to be a painter when in 1848 his parents decided he should either study law or, more to their son's taste, become a naval officer. He joined a cadet ship voyaging to South America but on his return in 1849 he again failed his naval examinations and was reluctantly allowed to enter the studio of Thomas Couture. He spent six years there (1850–56) and while he was often in terse disagreement with Couture, he developed great technical proficiency, a habit of copying work by past painters and the practice of drawing as he went about the Paris streets: 'any trifle – a profile, a hat – in a word, any fleeting impression that took his fancy', wrote his friend Antonin Proust. In the Louvre he copied Boucher, Rubens and Tintoretto. He visited Italy in 1853 and Holland, Belgium, Germany and Austria in 1856. In the previous year he had copied *The Little Cavaliers*, then thought to be by Velázquez, now ascribed to del Mazo, Velázquez's son-in-law. It was the first of Manet's many copies and interpretations after Spanish painting and the beginning of his life-long devotion to Velázquez – 'the painter to beat all painters', he wrote from Madrid in 1865. Throughout his life Manet stored visual images, particular colour harmonies, compositional features and individual figures which he used repeatedly in his work. Sometimes they are used very directly (*plate 3*), sometimes two or more sources are combined (*plate 18*) or he works personal variations on a previous genre as in his portraits of philosophers inspired by Velázquez. Some of these references were recognized when the paintings were exhibited; Manet was accused of a lack of originality, of a deliberate effrontery in presenting such blatant 'pilferings'. Few people understood the imaginative reprocessing of imagery that was at work.

While he was studying under Couture, Manet's disagreements centred on the artificiality of much that was taught – tiresomely posed models, the predominance of history painting, unrealistic lighting and the accepted method of introducing half-tones to avoid abrupt transitions from dark to light which gave a murky, subdued tonality to much contemporary painting. 'I can't think why I'm here,' he is reported as saying of Couture's studio; 'everything we see here is absurd; the light's false, the shadows are false. When I arrive at the studio I feel as though I'm entering a tomb.' Manet's reaction against the academic practice of his time has often been over-stressed. His technical innovations, while important, are never as radical as those of the Impressionists and we find precedent for them among the painters of the past such as Velázquez, Goya, Hals, Caravaggio and certain rococo painters of eighteenth-century France. Again, Manet has too frequently been presented as almost alone in the 1860s in embracing contemporary subject-matter and always at odds with his fellow artists (save Courbet). In fact the annual Salons which saw Manet's early triumphs and disasters contained innumerable slices of modern life, genre scenes with titles he might have used himself. And investigation has shown that Couture was a relatively liberal teacher, even encouraging his students to work out of doors, respecting the first spontaneous reactions to the landscape. What

distinguished Manet, and drew execration from the public, was his specific attitude to those themes, his conscious withdrawal of comment. He gave us naked women neither titillating nor idealized, recent historical events without the glamour of history, unelucidated figures, crowd scenes without incident, a Christ without tears.

The major pictures of Manet's earlier career include *Lola de Valence*, *Music in the Tuileries Gardens*, *Luncheon on the Grass*, *Olympia*, *The Balcony* and *Luncheon in the Studio* (*plates 6, 2, 3, 8, 18, 19*). Baudelaire once wrote of his friend's 'confirmed taste for modern truth' and nowhere is this better exemplified than in *Olympia*, his painting of a slim Parisian courtesan lying on her Indian shawl and sheets receiving homage from an admirer in the form of a bouquet presented by her maid. The strongly contrasted areas of light and dark, the virtual elimination of half-tones, the picture's shallow spatial recession and iconographic references to Titian and Goya — all contribute to the superb daring of Manet's conception. That this was a scene common in contemporary Paris, 'a demi-mondaine chez-elle', that the girl's look hauntingly blends invitation and self-assurance, that Manet makes no attempt at idealization or allows any semblance of moral comment to interfere with visual truth, all this inspired an unprecedented scandal when the painting was shown at the Salon of 1865.

Inevitably Manet was caricatured in the press as a Bohemian joker, 'a slovenly dauber' only intent on fooling the public. Emile Zola came to his defence. The articles he wrote cost him his position with the paper 'L'Evénement' in 1866; further articles appeared as a pamphlet in 1867 (which can be seen on the desk, bearing Manet's signature, in the *Portrait of Emile Zola, plate 16*). Zola alludes to Manet's love of society — balls, soirées, café life and the races — but emphasizes his assiduous working habits and quiet domestic life. In 1863 Manet had married his mistress, a young Dutch woman, Suzanne Leenhoff, originally a piano teacher in the Manet household. Ten years before, she had given birth to a son, Léon-Edouard, who appears in several of Manet's paintings, most notably *Luncheon in the Studio* (*plate 19*). In 1862 Manet's father had died, a fact which precipitated his marriage and left him financially comfortable; Mme Manet senior was often numbered in the household, particularly on Manet's visits to the family property near Gennevilliers, north-west of Paris. Several summer holidays were taken at Boulogne; there was a visit to Holland in 1872 and to Venice in 1875. During the Franco-Prussian war (1870–71), while his family were in the Pyrenees, Manet served as a lieutenant in the National Guard (as did Degas), and wrote some vividly descriptive letters of Paris under siege. By that time, Manet was at the centre of an admiring group of friends who frequently met at the Café Guerbois (and later at the Nouvelle Athènes) — Zola, Mallarmé (*plate 30*), the writer and critic Edmond Duranty, Whistler, Degas and Fantin-Latour. At the Salon of 1870, Fantin-Latour exhibited a large group-portrait of Manet working at his easel surrounded by friends who include Zola, Frédéric Bazille, Renoir and Monet. Manet is seen in the picture as a leader of the younger painters; it is worth considering how this came about.

The history of French nineteenth-century painting can be read as a long liberation and within this movement Manet's place has been held conspicuous if not always pre-eminent. His development of a method of painting commensurate with an essentially modernist vision gave a vital lead to some of those independent painters who began to exhibit collectively in 1874 and became known, through a journalistic slur, as the Impressionists. Manet was never an Impressionist but from about 1868–9 he came close

to certain Impressionist tenets — introducing more brilliant, pure colour, working out of doors, developing a fresh, synoptic handling in such pictures as *The Departure of the Folkestone Packet (plate 21)* and *Road-Menders in the Rue de Berne (plate 31)*. This rendering of immediate impressions — a physical celebration as we see it for example in Renoir and Monet and Pissarro — was contrary to Manet's usual practice in the 1860s and played small part in his aesthetic temperament. As one critic has written, '. . . Manet was never primarily a painter of landscape or reflected light, he never abandoned local colours or black, and most of his works were executed in the studio, from drawings made in front of the subject itself' (Phoebe Pool, *Impressionism*, p. 136). One might add that in contrast to the Impressionists in the 1860s and 1870s, Manet was invariably searching for a monumental configuration to present his view of reality. His instinct was towards ample form, forceful, unbroken contours and as direct a statement as possible of dark and light areas. The influence initially of Berthe Morisot (see *The Game of Croquet, plate 25*) and later of working with Renoir and Monet at Argenteuil continued to affect Manet's work until his death. His composition becomes less highly wrought, less compressed; his response has a gaiety and charm reminiscent of Renoir; a fastidious sensuality of handling equals the sunlit relaxation of his subjects. His brushwork becomes more physically explicit as a means of perceptual expression; the re-creation of objects acquires greater urgency, without losing a characteristic elegance, which is rarely seen in his work of the 1860s.

Is it still possible to concur with several earlier writers on Manet that the period following his closest contact with the Impressionists sees a decline in his painting? Certainly there are paintings of the early 1870s which appear slack and unresolved. Sometimes a vignette-like element reduces the conceptual tension of certain works. We can observe its corrosive effect in *At Père Lathuille's* and such a resounding success as *Argenteuil* comes near to an anecdotal situation, partly saved by the woman's withdrawn and even gaze. Looking at the paintings of his last decade we see Manet searching for contemporary subjects which would extend the formal discoveries of his earlier work — the 'random' quality of *On the Beach at Boulogne (plate 22)*, the spatial contrasts of *Luncheon in the Studio*. He achieves this most strikingly in those scenes of urban life (from the late 1870s onwards, culminating in the *Bar at the Folies-Bergère, plate 38*) whereby a complicated structural organization records the effervescent mobility of life passing in front of the viewer's eyes. The newly found flexibility and emotive possibilities of his brushwork find their fullest expression in these reclamations of a moment in time.

It is in these later paintings that Manet shows his assured assimilation of aspects of photography and Japanese art. Of the former he sometimes made direct use but more frequently we see it in the changes of focus within a picture, the merging of one form into another, his use of grey tones and the particular stare of his models (the maid in *Luncheon in the Studio*, for example, or Berthe Morisot in *plate 20*). The influence of Japanese art shows itself most noticeably in Manet's graphic work (for example his lithographs to Mallarmé's translation of Poe's *The Raven*), but such a painting as *Boating (plate 28)*, with its raised viewpoint and intercepted forms, would also be inconceivable without the example of Japanese art — to which Manet had paid overt tribute in his portrait of Zola.

Contemporary methods of stage presentation, fashion plates, broadsheets also contribute to the dense and allusive stylistic vocabulary of his later years. Yet nothing seems forced or mannered; our eyes move with ease

over the varied perspectives he offers, here taking in a face, an amusing hat, there a parasol or a glass of beer. Yet how often we are checked by a pair of eyes that seem to draw us into the picture and yet impose a distancing melancholy on the possibilities of such a confrontation – the woman in *Skating*, the look almost of alarm in *The Waitress*, Nana turning from her mirror to gaze at us, the resigned but vulnerable regard of the barmaid at the Folies-Bergère. 'Sorrow is at the root of all humanity and poetry,' Manet said towards the end of his life; such chastening moments of apprehension run through his work, coaxed from the impartial contemplation of the scene before him.

In spite of Manet's association with the Impressionists during the 1870s, he continued to send his work to the Salon; *Le Bon Bock* was a success there in 1873 and further paintings had a mixed reception. In 1874 *Boating* was favourably received and two years later a portrait gained him a second-class medal; at the end of the year he was made a Chevalier de la Légion d'Honneur. By that time Manet was considerably handicapped by locomotor ataxia, a disease of the central nervous system. He took innumerable cures in spa towns but to no avail. He worked on a smaller scale (*The Bar at the Folies-Bergère* was his last large painting) and in the physically less demanding media of pastel and watercolour. By April 1883 it was decided that one of his legs must be amputated, gangrene having set in; ten days later Manet died in Paris on 30 April, aged fifty.

The subjects of the major paintings of Edouard Manet are all passionately interesting for themselves. He shares with few other painters since his time an ability to create memorable, figurative images through the use of informal, mysterious or 'incomplete' gestures; so often his people seem suspended amidst their habitual activities – *The Street Singer* and the trio in *The Balcony* are particularly characteristic. By his concentration on the varied rhythmic possibilities of his models, he gives us 'that intimate sense of the inner life of the figure'. We can see this in Courbet, in some of Degas' portraits, in Picasso's early work. At the same time Manet's technical variousness – his changes of tension, perspectival and spatial distortions, the juxtaposition of suave and broken surfaces, together produced a feeling of intellectual power beyond the ambitions of most of his contemporaries, and which led to the art of the twentieth century. His modernity of vision and, more precisely, its specifically urban complexion made a profound impression on the art of his time. During the twenty years which separate *Concert in the Tuileries* from *The Bar at the Folies-Bergère*, the realist movement in France contributed a series of masterpieces which take the urban milieu as their theme: Renoir's *Moulin de la Galette*, Degas' *Café-Concert*, Monet's views of the Gare St Lazare and Seurat's *Baignade, Asnières*, which he began in the year of Manet's death. Just as Seurat situates his classic theme on the democratic banks of the Seine, so Manet had reacted with instinctive clarity to the world about him. But we return constantly to his means – his intense stylishness, his personal colour, an inventive application of paint as the only instrument for conveying his investigations of visual appearances. Through this we can understand something of Cézanne's comment that '. . . Our Renaissance begins there.'

1. *The Old Musician*

1861–2. Oil. 74 × 97¼in (188 × 247cm)

Manet's early interest in genre and picturesque subjects found its most ambitious expression in *The Old Musician*, which was derived from an engraving by Goya after Velazquez's *The Topers*. The cloaked and hatted onlooker to the right is based on an earlier painting by Manet, *The Absinthe Drinker* (1858–9). Although subjects like *The Old Musician* were perfectly familiar to Salon visitors at the time, what was found disturbing in this picture was the loose compositional treatment of the sequence of figures.

Washington DC, National Gallery of Art

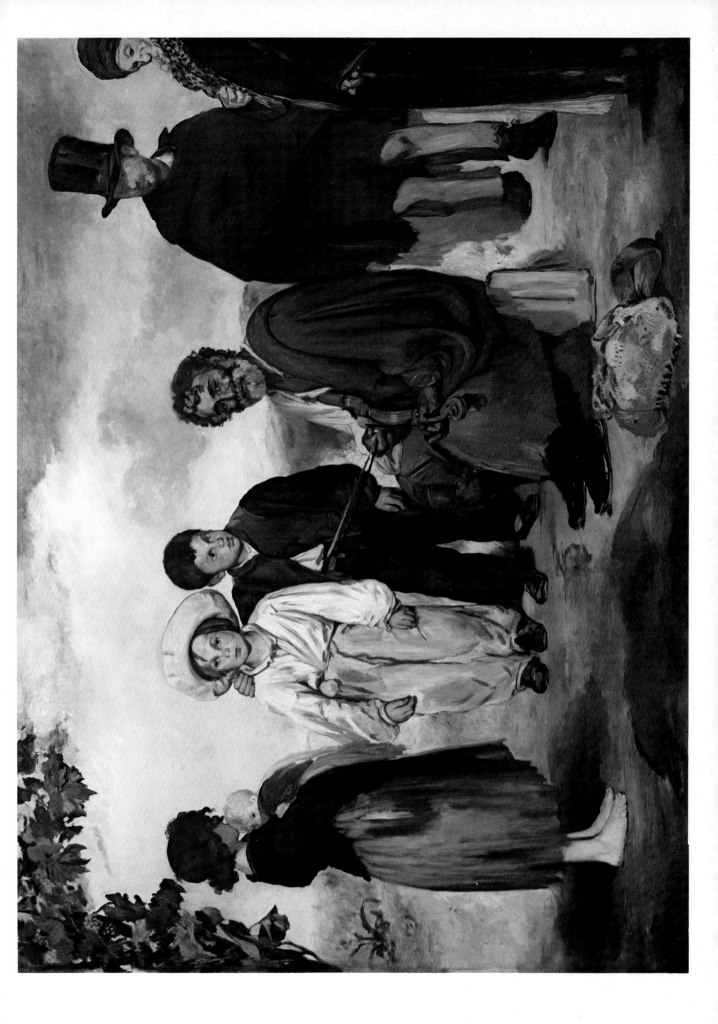

2. Music in the Tuileries Gardens

1862. Oil. 30 × 46½in (76 × 118cm)

Here is the first masterpiece embodying Manet's reactions to that 'spirit of modern life' which Baudelaire commended to the contemporary artist. The painter and several of his friends mingle with the fashionable crowd in the Tuileries (Manet is on the extreme left; Baudelaire, Gautier and Offenbach also appear). Already Manet shows a preference for certain colour combinations which he continued to explore – ochre, pale blue and muted red – here accentuated by the glancing blacks of the men's clothes and hats; the whole painting is structured by the arabesques of the trees. As well as sketches made in the gardens, Manet possibly used photographs while painting the work in the studio.

London, National Gallery

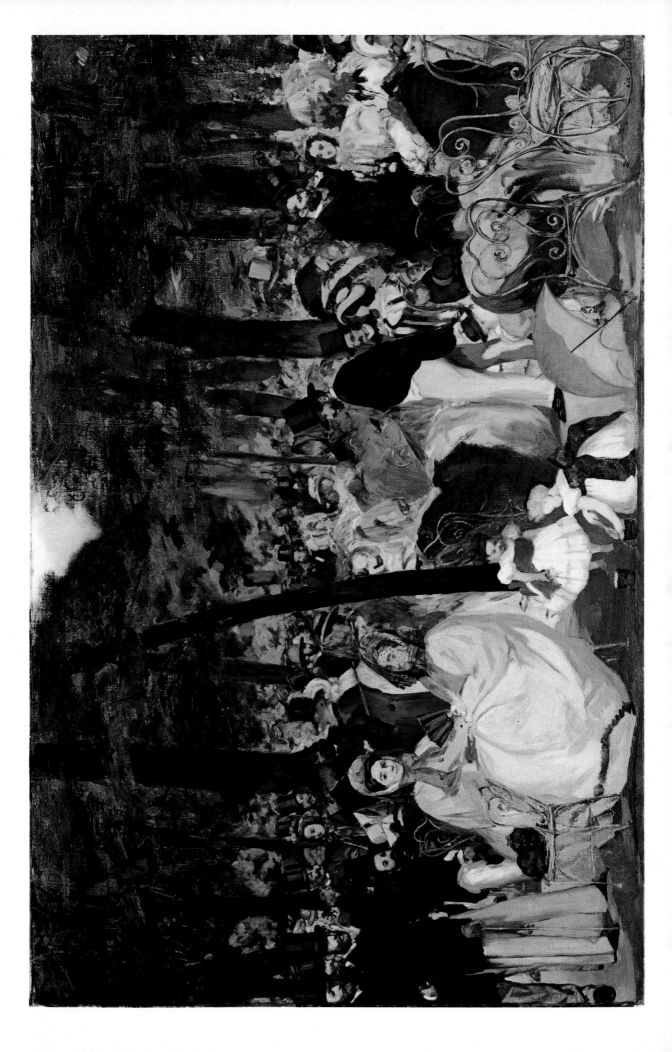

3. *Luncheon on the Grass*

1862–3. Oil. 35¼ × 43¾in (89·5 × 111cm)

An oil sketch for the painting in the Louvre which
caused such an uproar at the Salon des Refusés of 1863.
Manet's favourite model, Victorine Meurend, is shown
with the painter's brother, Gustave, and future
brother-in-law, Ferdinand Leenhoff. Their grouping is
based on an engraving by Marcantonio Raimondi after
Raphael; the picture's overall impulse came from
Giorgione's *Concert Champêtre* in the Louvre and the
visual starting point was the sight of a group of bathers
at Argenteuil. Throughout his career Manet reconstituted
a variety of images taken from the work of other artists,
photographs and printed ephemera.

London, Courtauld Institute Galleries

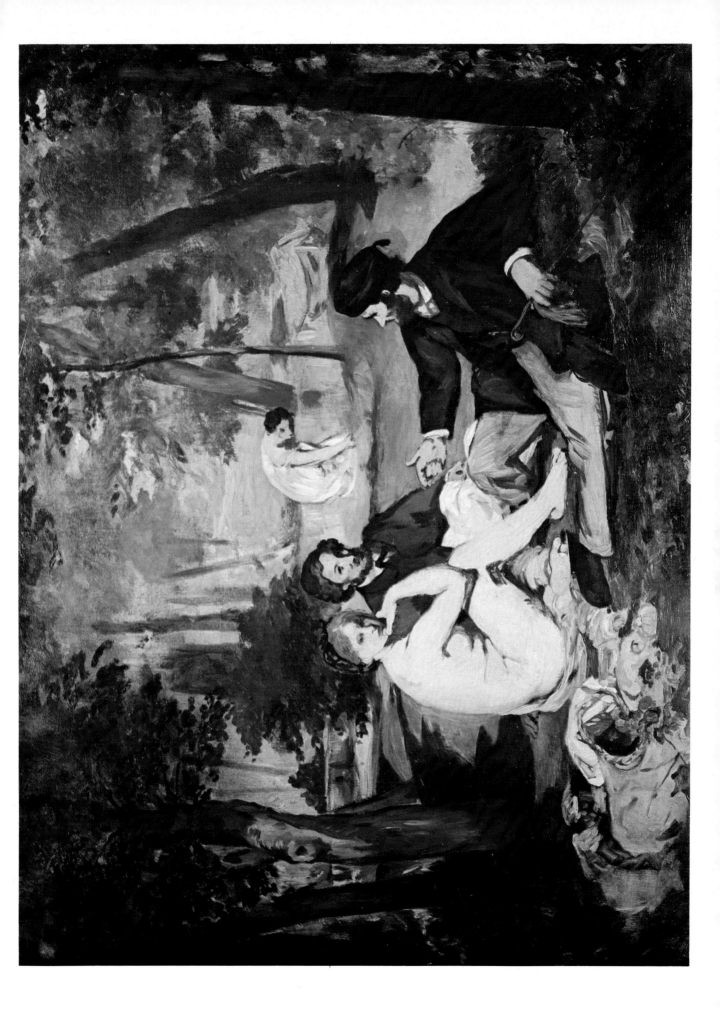

4. *The Street Singer*

1862. Oil. $68\frac{1}{2} \times 46\frac{1}{2}$in (174 × 118cm)

Walking at night in Paris, Manet chanced upon a woman with a guitar leaving a brasserie. She refused to pose and once more Victorine Meurend dressed the part, meditatively stepping into the street eating cherries, the guitar at her side. It has frequently been noted that the composition owes something to Japanese prints and also to photography. It is perhaps the most haunting of all Manet's depictions of urban life and also one of the most concise in its bounding contour and simplicity of handling.

Boston, Museum of Fine Arts

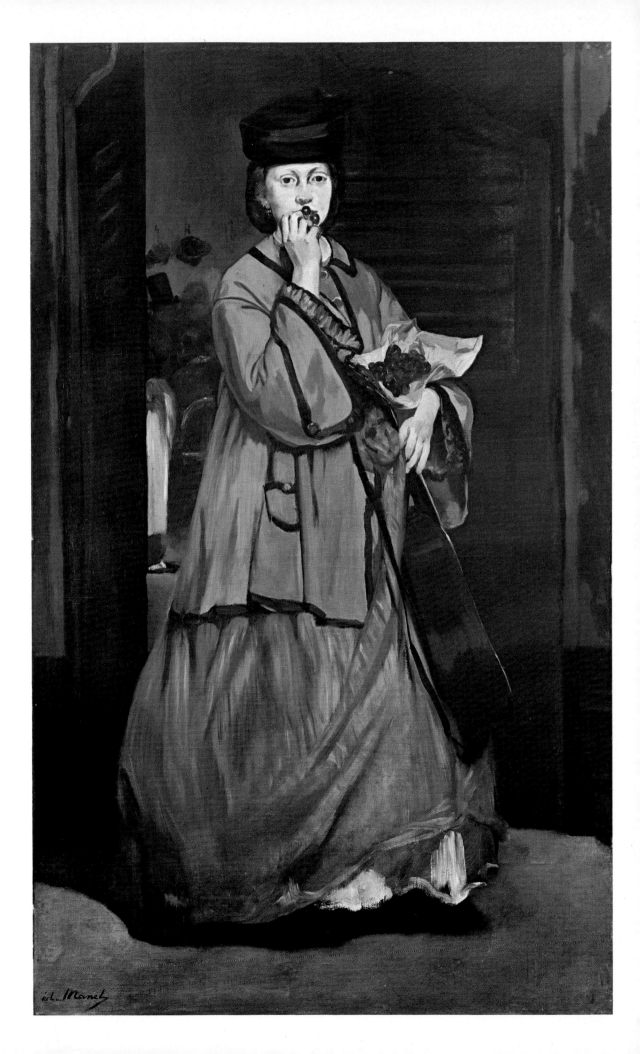

5. *Mlle Victorine as an Espada*

1862. Oil. 65 × 50¼in (165 × 128cm)

French response to Spanish culture has a long history; in the nineteenth century it began with certain romantic writers, and was continued by Manet and composers such as Chabrier and Bizet (*Carmen* was first performed in 1875), and later by the orchestral impressionism of Debussy and Ravel. In the 1860s Manet painted a series of works inspired by the bullring, Spanish music, dancing and costume. It was to Spain that he fled after the scandal caused by *Olympia*'s appearance at the Salon in 1865. Two of his paintings show women dressed in male Spanish attire; in this one both subject and treatment derive from Spain.

Paris, Louvre

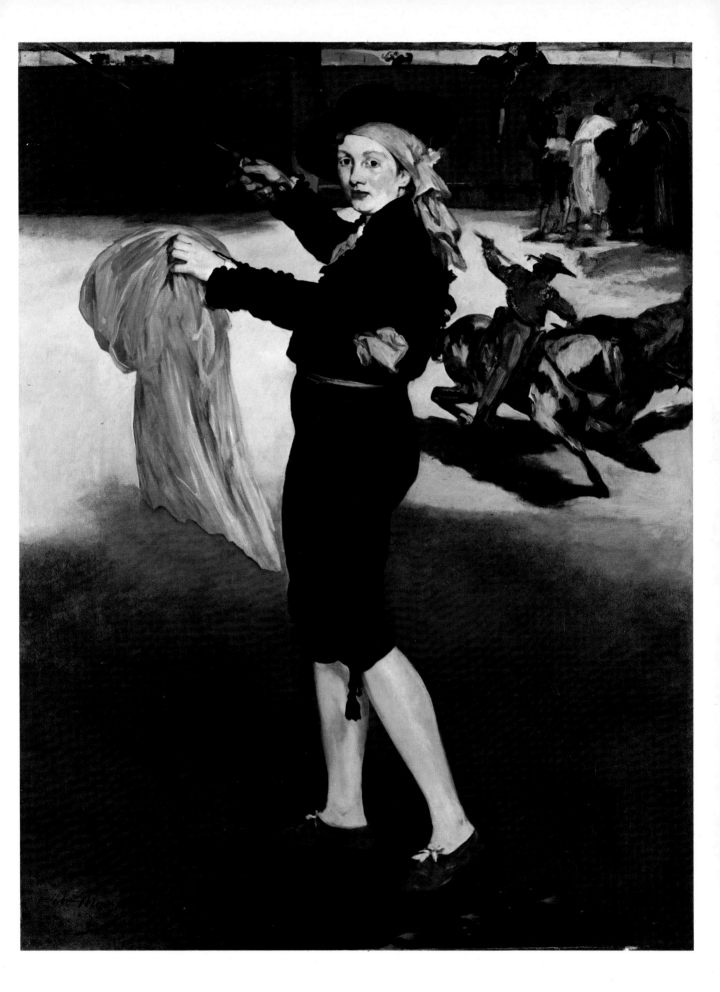

6. *Lola de Valence*

1862. Oil. $48\frac{3}{8} \times 36\frac{1}{4}$in ($123 \times 92$cm)

A superb 'publicity shot' of Lola de Valence, a Spanish dancer popular in Paris who worked with the Camprubi ballet company. We see her isolated against the wings of the stage much as Mlle Victorine is extracted for a moment from the activities of the bullring (*plate* 5). Changes of focus such as these are found throughout Manet's work; the direct, frontal lighting flattens the dancer's features and allows a maximum intensity of colour in the skirt.

Paris, Louvre

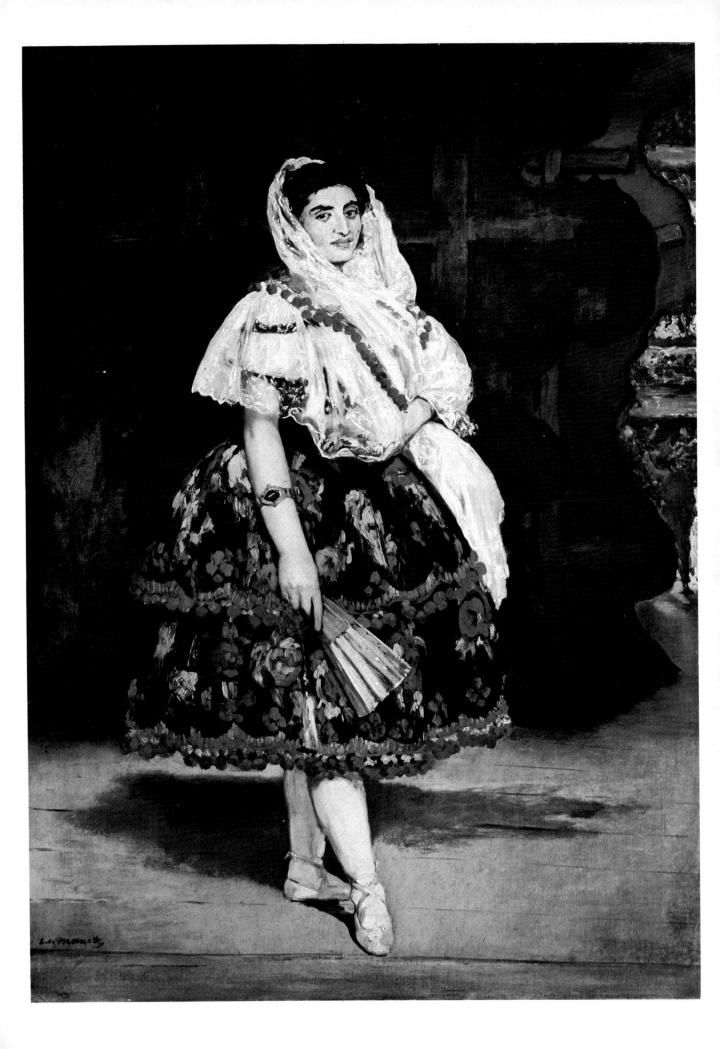

7. Dead Toreador

1863–4. Oil. 29½ × 60½in (75 × 153·5cm)

Between 1864 and the Salon of the following year
Manet destroyed a large painting, *Episode in the Bullfight*,
but retained two fragments, the present work and *The
Bullfight* (Frick Collection, New York). The figure was
taken from a painting then thought to be by Velazquez,
Orlando Muerto (National Gallery, London) but which is
now attributed to an Italian seventeenth-century artist.
The impact of the body – its distilled immobility,
clinically observed and beautifully painted – is
strengthened by its removal from the dramatic
'narrative' of its origin. Emotion through restraint and
enigmatic contrast is a hallmark of Manet's work.

Washington DC, National Gallery of Art

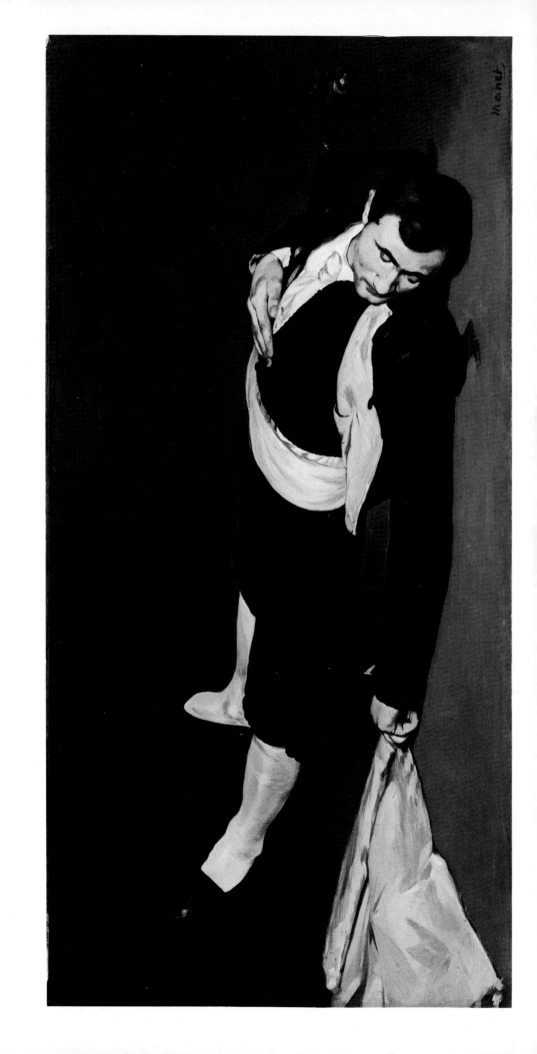

8. *Olympia*

1863. Oil. $51\frac{1}{8} \times 74\frac{3}{4}$in ($130 \times 190cm$)

Manet considered *Olympia* his masterpiece — this slim young 'demi-mondaine', her urban pallor emphasized by the luxurious coverings of her bed, the flowers brought in by her attendant and the cat, hissing that we keep our distance. She has the persistence of an icon, inviolate in her self-assurance. Although the painting remained with Manet, it was reproduced and exhibited; Cézanne was bowled over by it as a young man, and Gauguin copied it. Through the initiative of Claude Monet and others, it was presented to the nation (although not without considerable resistance) and entered the Luxembourg Collection in 1890, twenty-five years after the storm it had aroused at the Salon of 1865.

Paris, Louvre

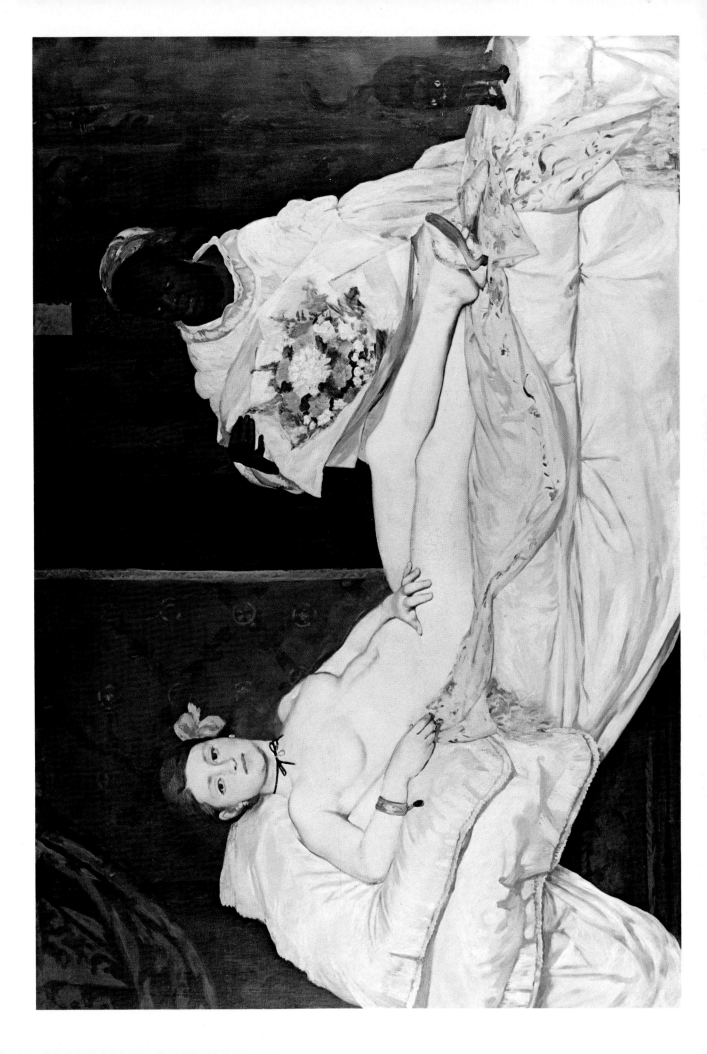

9. *Dead Christ with Angels*

1864. Oil. 68⅛ × 61in (173 × 155cm)

There are only two paintings by Manet which are biblical in inspiration, this and *Christ Crowned with Thorns* in Chicago. The *Dead Christ* was generally execrated by those who saw it at the Salon of 1864, scorned for its coarse treatment of the figure of Christ, 'a corpse painted in full daylight with freedom and vigour,' as Zola wrote. In its concentration on the physical reality of death it takes its place among other contemporary manifestations, in literature especially, which aimed at a stripping away of 'grandiloquent and elevating imagery' to present a more down-to-earth restatement of the truth.

New York, Metropolitan Museum

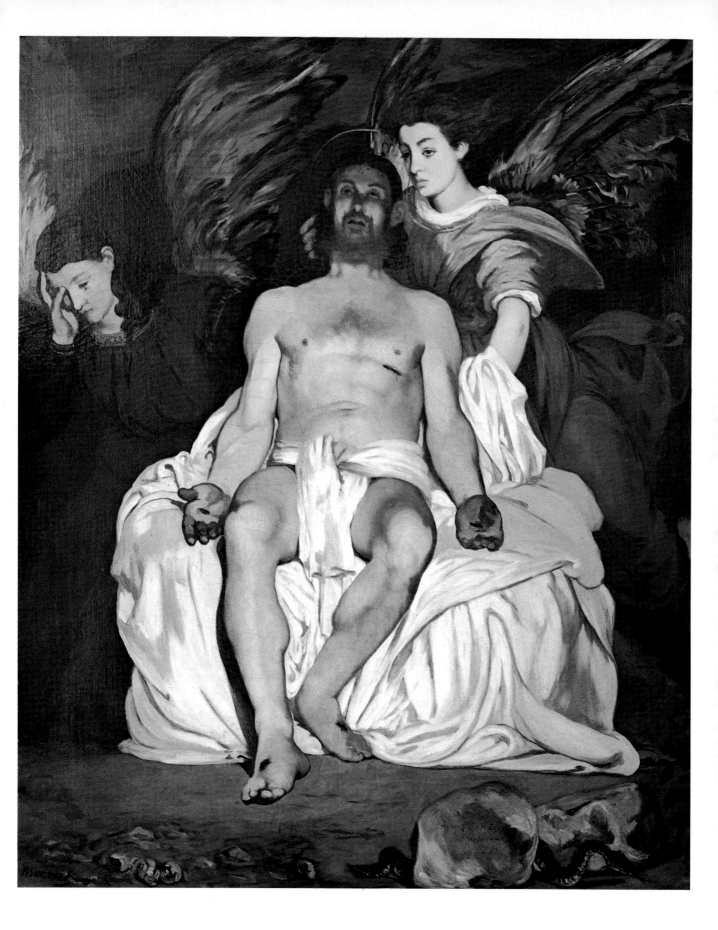

10. *Two Peonies and Secateurs*

1864. Oil. $12\frac{3}{8} \times 18\frac{1}{4}in$ ($31 \cdot 5 \times 46 \cdot 5cm$)

The particular species of peony painted by Manet on many occasions was introduced into Europe early in the nineteenth century and was regarded as a luxury flower. Manet grew this type in the garden of his family home; just as his still lifes often show fine linen and glass and elegantly prepared food, his favourite flowers were peonies and roses with their exotic associations. At the end of his life, incapacitated by disease, he produced several small pictures of flowers notable for their springing vivacity, in contrast to the opulent creams and reds of the series of peonies. A white one can be seen in the portrait of Eva Gonzalès (*plate 23*).

Paris, Louvre

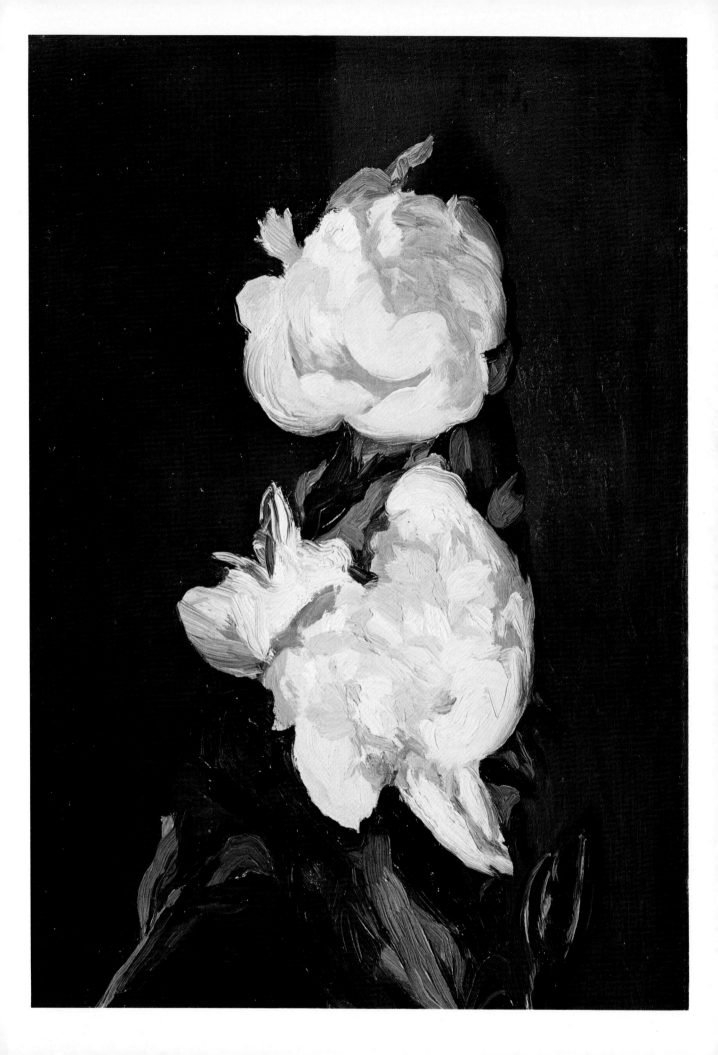

11. *Women at the Races*

1864–5. Oil. 16⅝ × 12⅝in (42 × 32cm)

This is a fragment from a large painting of a race-course which Manet cut up as he had the *Episode in the Bullfight* and was to do with a version of the *Maximilian* (*plate 17*). Brisk, synoptic brushstrokes (particularly in the skirts and carriage wheel) convey the movement and gaiety of the course as well as the pertly realized characters of the two women. One is reminded of Manet's habit, as a student, of sketching in the streets 'any fleeting impression that took his fancy'.

Cincinnati, Art Museum

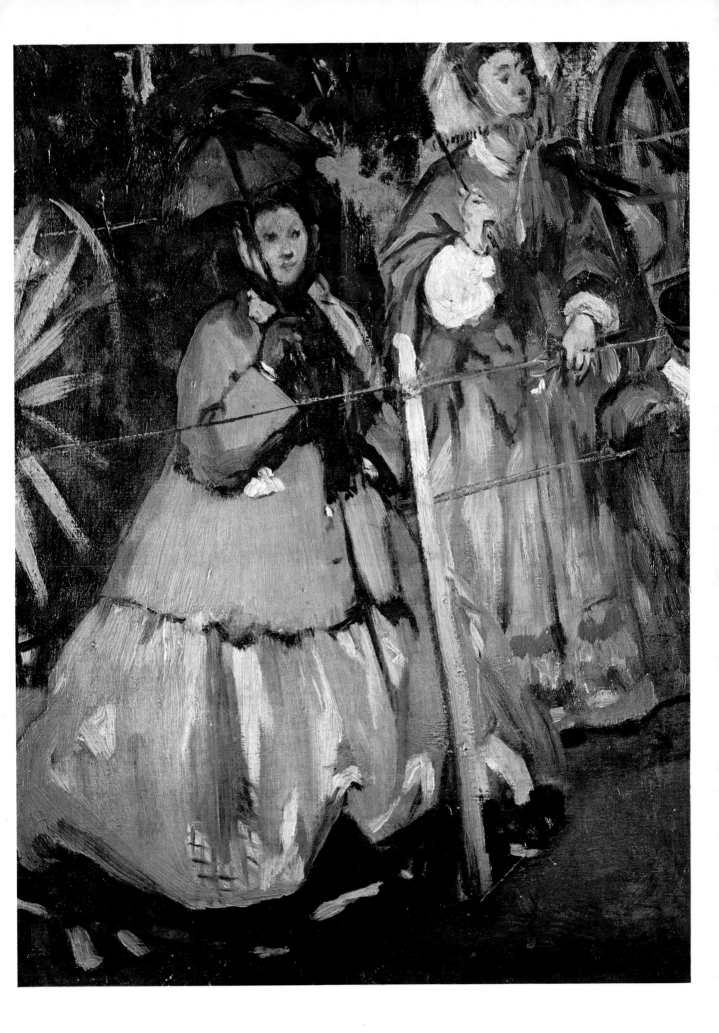

12. *Races at Longchamp*

1864. Oil. $17\frac{1}{4} \times 33\frac{1}{4}$in ($44 \times 84\cdot5cm$)

The two women in the previous plate might well take their places among the vividly suggested spectators on the left of this painting of a fashionable race-course. It is unusual in that we seem to be situated on the track right in the path of the horses, thus gaining maximum immediacy. Manet has chosen to represent dashing movement, rare in a body of work noted for its contemplative stillness.

Chicago, Art Institute

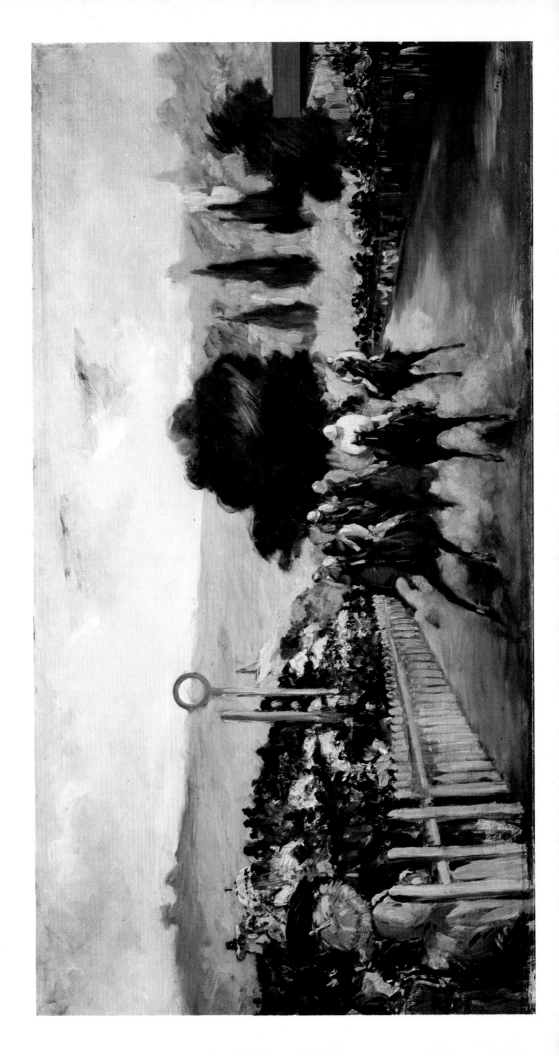

13. *The Fifer*

1866. Oil. 63 × 38½in (160 × 98cm)

One of the great works of Manet's maturity is this image
of boyhood thrust into the official world of adult life,
much as the boy seems swamped by his military clothes.
Manet's stepson Léon Koëlla posed for the face of the boy
which yet is strangely reminiscent of Victorine Meurend's
impassive gaze. Again Manet has lit his model from the
front, strengthening the outline (emphasized by the black
stripe of the trousers) and minimizing shadow, giving
to the picture the flatness of a playing card.

Paris, Louvre

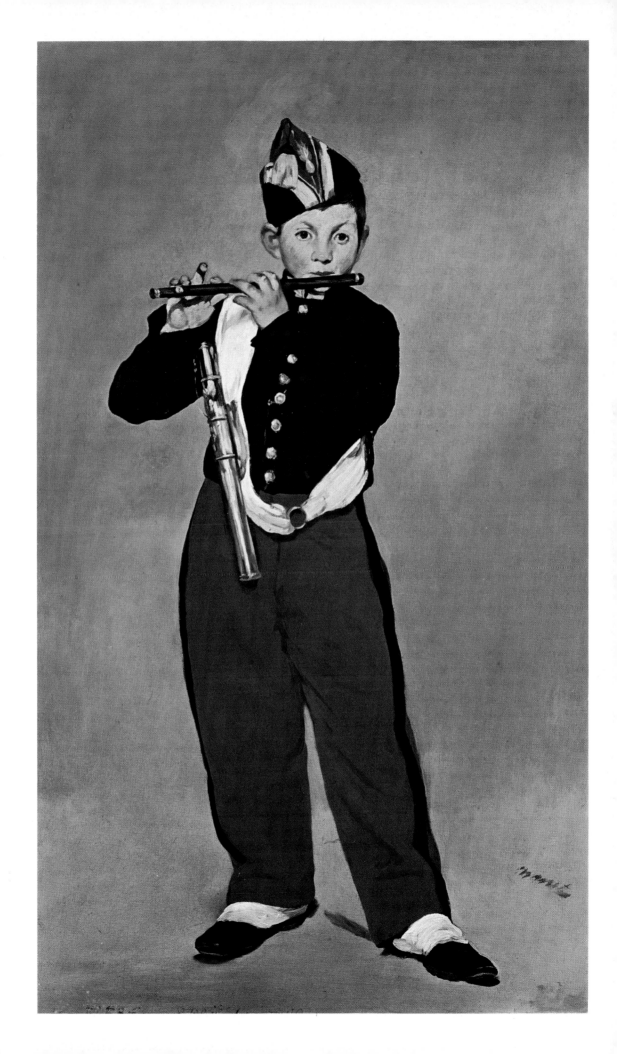

14. *Boy Blowing Soap Bubbles*

c.1867. Oil. 39 × 32in (100 × 82cm)

Manet returns here to the type of genre subject which he had painted in the early 1860s. His young studio assistant Alexandre posed for the famous *Boy with Cherries* (also in the Gulbenkian Collection) and Léon Koëlla for such works as *Boy with a Sword*, *The Urchin* and the present painting, undoubtedly inspired by Chardin's several treatments of the same subject. Note especially the restricted colour range, the simplified drawing of the boy's head and Manet's increasing fluency in the handling of paint.

Lisbon, Gulbenkian Collection

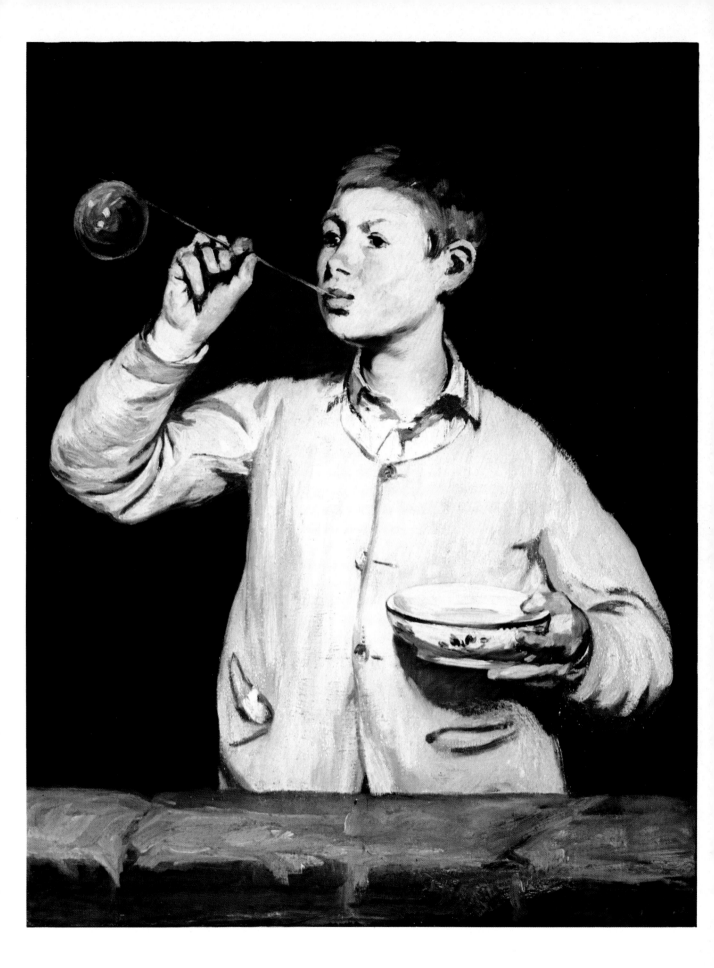

15. *Woman with a Parrot*

1866. Oil. 73 × 52in (185 × 132cm)

This life-size painting was shown at the 1868 Salon along with the portrait of Emile Zola (*plate 16*). It is one of Manet's most ravishing colour harmonies, certainly influenced by Velazquez whose work was fresh in his memory from his visit to Spain in the previous year. This is particularly apparent in the little-varied, spatially ambiguous background found in some Velazquez portraits. The gaze of the woman, as she pensively holds a bunch of violets to her nose, imposes on the spectator a distancing melancholy which is frequent in Manet's work, whether in individual portraits or in groups, from which one person looks out, as in *Skating* or *The Waitress* (*plates 33, 36*).

New York, Metropolitan Museum

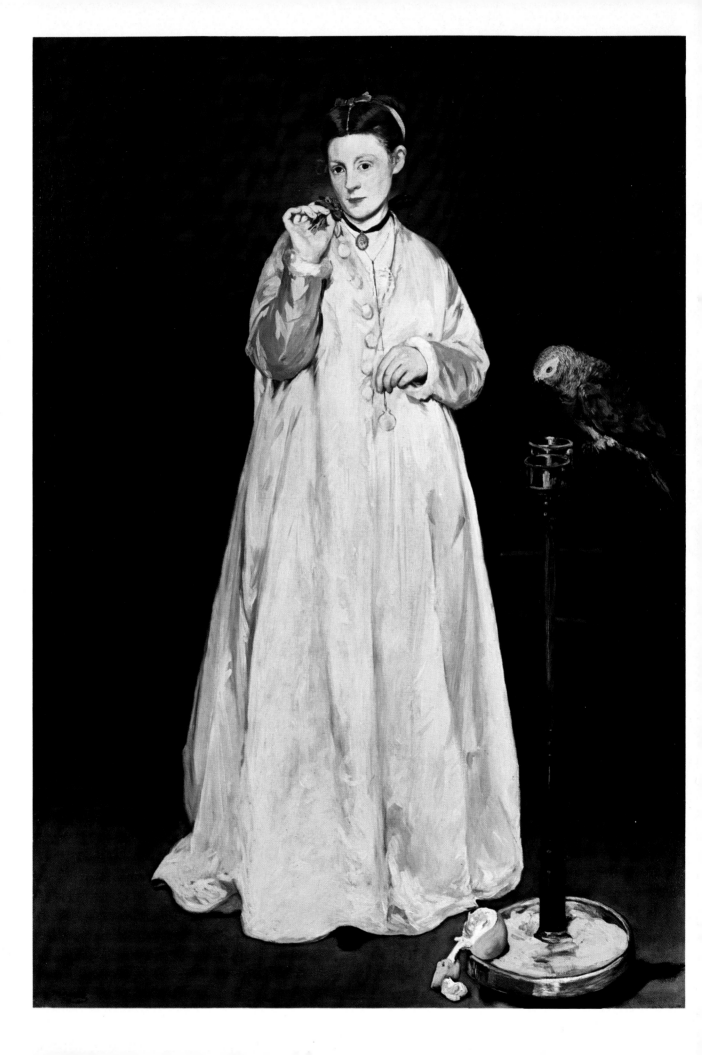

16. *Portrait of Emile Zola*

1868. Oil. 57 × 43⅝in (145 × 111cm)

Painted as a tribute to the young novelist and critic who had championed Manet, Emile Zola (1840–1902) is seen at his desk; behind the quill pen is his pamphlet on Manet (its title serving as signature); on the wall we see various allusions to Manet's career – a miniature manifesto – including a photograph of *Olympia*, Goya's engraving of Velazquez's *The Topers* and a print by Utamaro. The Japanese screen also suggests a debt borne out by the composition of the portrait. Zola wrote of Manet as a man 'subtle and courageous . . . of extreme amiability and exquisite politeness, with a distinguished manner and a sympathetic appearance'. The picture was given to the Louvre in 1918 by Zola's widow.

Paris, Louvre

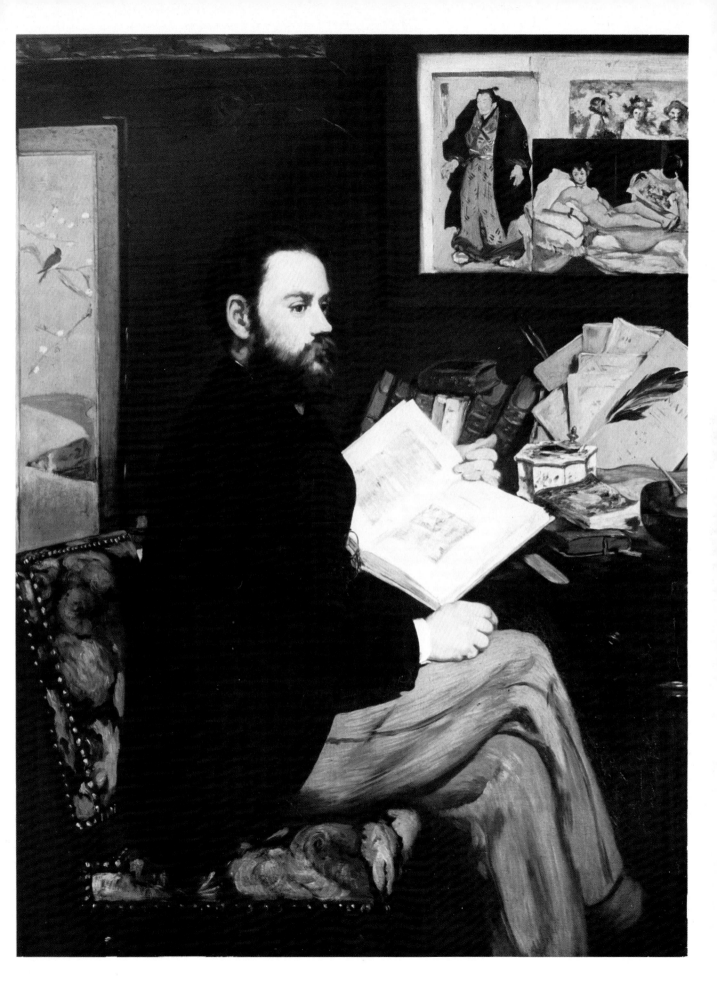

17. *Execution of Emperor Maximilian*

1867–8. Oil. 99$\frac{1}{4}$ × 120in (252 × 305cm)

In 1867 Emperor Maximilian of Mexico (the brother of the Emperor Franz Joseph of Austria) was captured by the republicans after the withdrawal of the French who occupied Mexico in 1864. On 19 June Maximilian and two generals, Miramon and Mejia, were executed by firing squad. Manet painted four versions of the subject, an unfinished one (in Boston, Mass.), a sketch (in Copenhagen), this one and another which was subsequently cut up; some of its fragments, owned by Degas, are in the National Gallery, London. Manet worked closely from newspaper reports and photographs as they gradually appeared in the French press, and they give to the painting a detachment which reinforces the horror of an incident which deeply moved the painter.

Mannheim, Städtische Kunsthalle

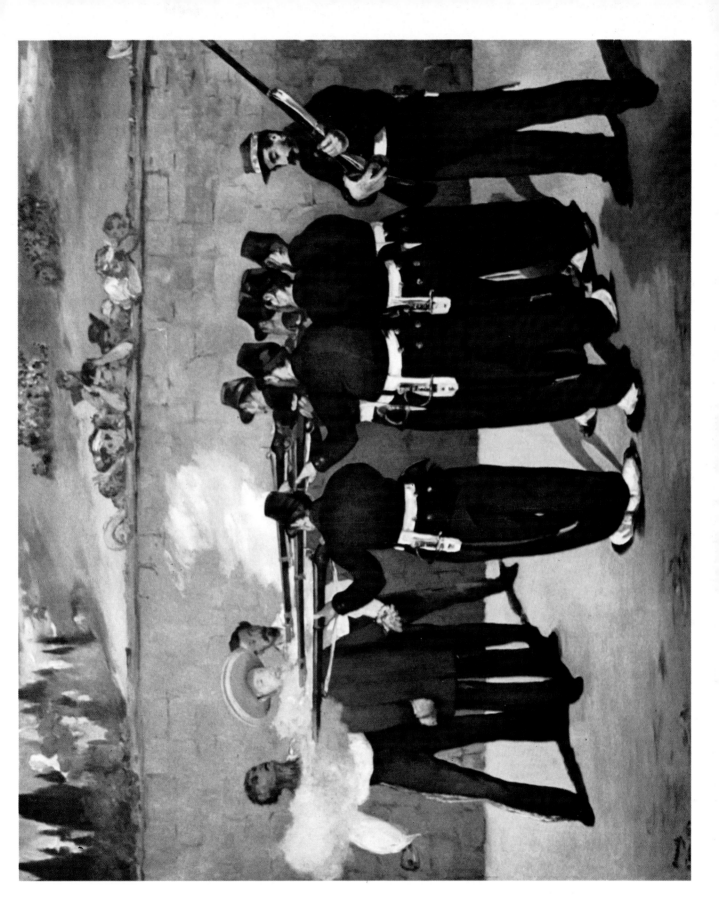

18. *The Balcony*

1868. Oil. $66\frac{1}{2} \times 48\frac{1}{2}$in (169 × 123cm)

The sight of some people on a balcony in Boulogne was Manet's initial inspiration for this work. It was painted in Paris, Goya's *Majas on the Balcony* determining the overall scheme if not the psychological relationships of the figures. Berthe Morisot is on the left, and Fanny Claus, a violinist, on the right. Behind the painter and collector Antoine Guillemet can be seen the figure of a boy taken from an earlier etching of Léon Koëlla. Baudelaire wrote of modernity as 'the transitory, the fugitive, the contingent, one half of art, of which the other half is the eternal and immutable'. It was in works such as this that Manet disconcerted his contemporaries with a strange combination of quotidean observation (the clothes, personal gestures) and the abstraction of his figures in some timeless reverie. The brilliant green balcony seems to preserve them forever as spectators of a world from which they have withdrawn.

Paris, Louvre

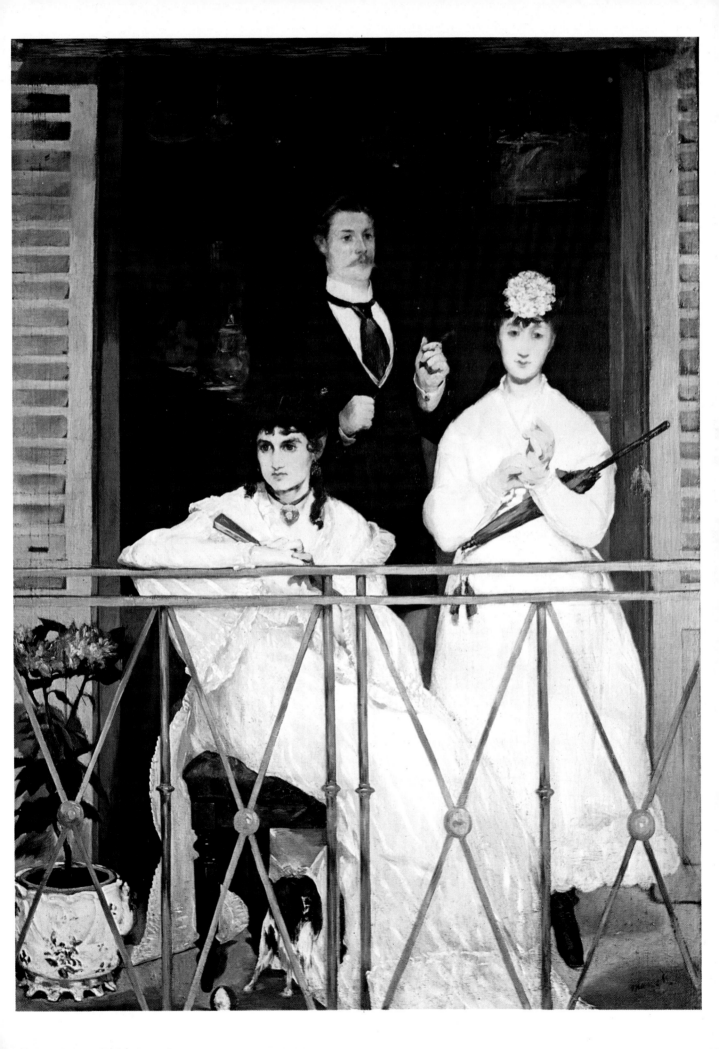

19. *Luncheon in the Studio*

1868. Oil. $47\frac{1}{4} \times 60\frac{1}{2}$in (120 × 154cm)

Several of Manet's preoccupations in the 1860s find
consummate expression in this masterpiece of his early
maturity. He shows us an everyday situation — luncheon
is over (although the oysters are uneaten), the young
man is about to leave, perhaps — yet suspends the whole
action in time, ridding it of narrative, giving the scene a
curious permanence. The serving woman is an
embodiment of this suspension as she looks out of the
picture, coffee-pot in hand, suddenly halted in her work.
The mysteriousness of the painting relies heavily on the
subtle range of greys scaled between the black and white
of the young man's clothes.

Munich, Alte Pinakothek

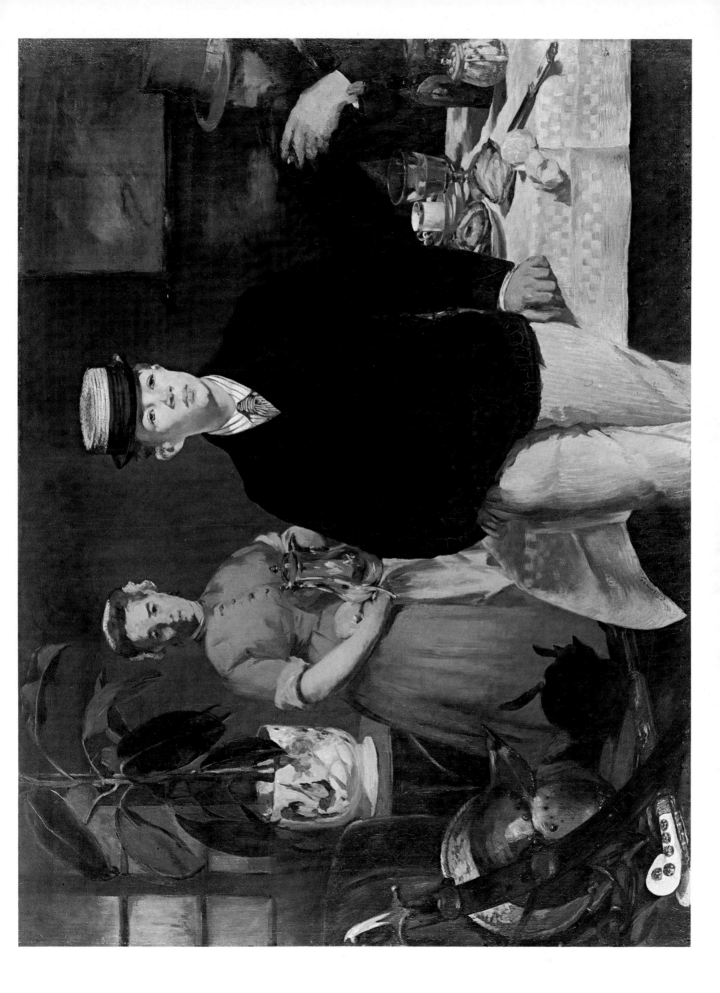

20. *Repose*

1869. Oil. $58\frac{1}{4} \times 43\frac{3}{4}$in (173 × 111cm)

The painter Berthe Morisot (1841–95) sat on several occasions for Manet who in 1874 became her brother-in-law when she married Eugène Manet. She had received lessons from Corot and was influenced by Manet after meeting him in 1858. In turn she had considerable effect on his work in the early 1870s when she exhibited in the first Impressionist Exhibition. Here she is seen lounging on a sofa, one leg tucked underneath her, dark-eyed and pensive, a large Japanese print behind her. *Repose* was exhibited at the Salon in 1873.

Providence, Rhode Island, Museum of Art

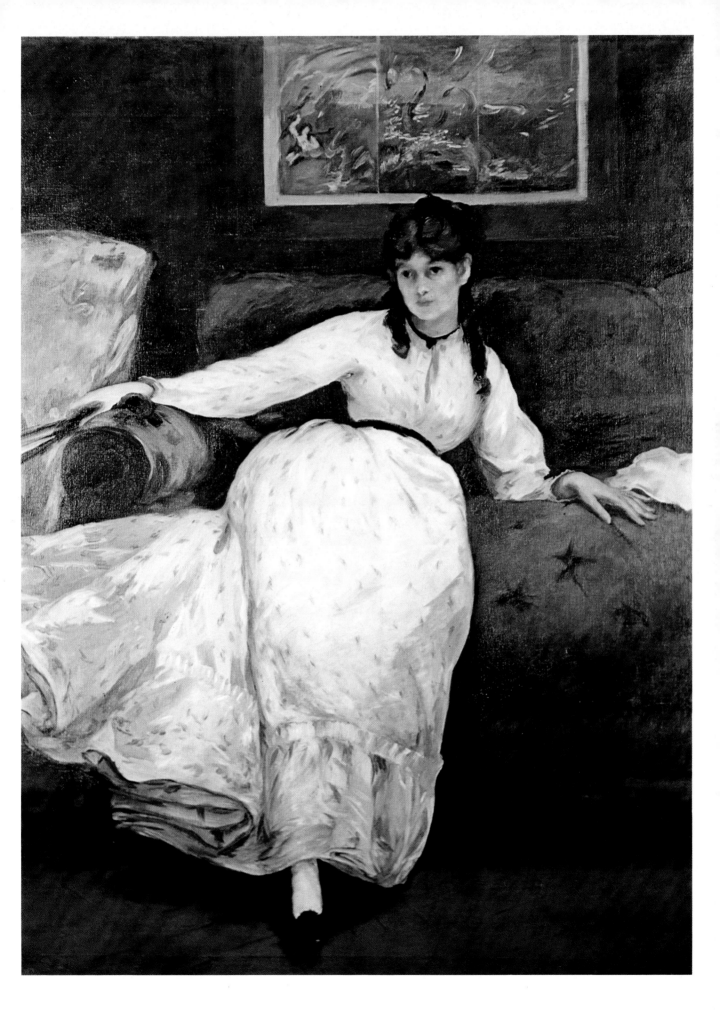

21. *Departure of the Folkestone Packet*

1869. Oil. 23¼ × 28in (59 × 71cm)

Manet and his family summered at Boulogne in 1869
and this and the following plate belong to that stay;
both are outstanding among the works of the transitional
period undergone by Manet as a result of his friendship
with Berthe Morisot, Monet and Degas. The fashionable
passengers and vivid sunlight are evoked with a new
verve and opulence in the brushwork. Strong dark notes
accentuate the colours of the women's skirts much as
they had in *Music in the Tuileries Gardens (plate 2)*.

Philadelphia, Museum of Art

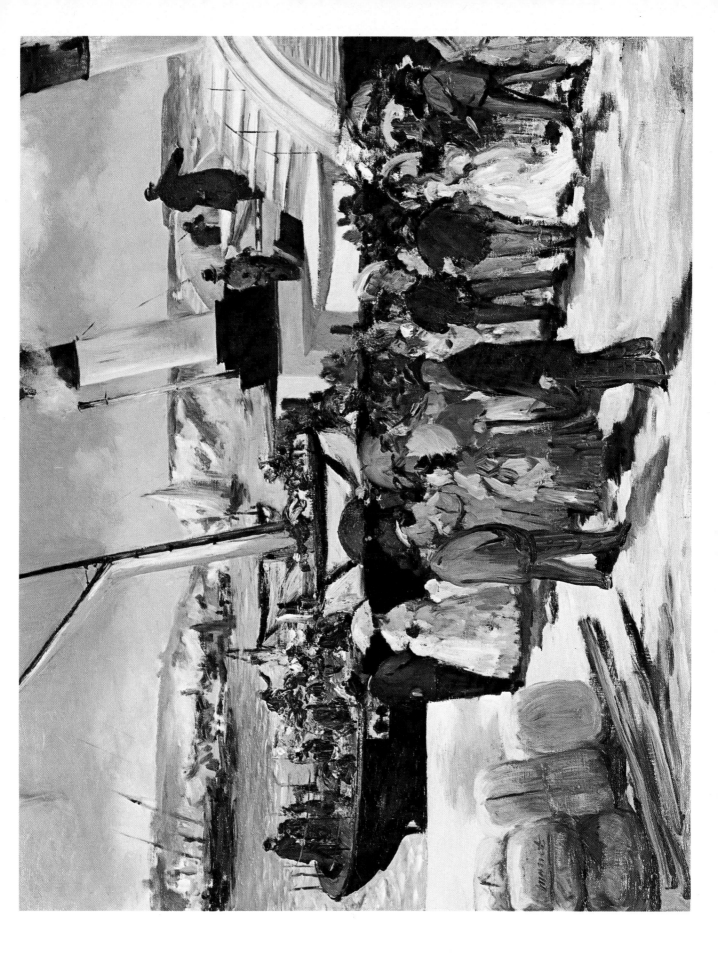

22. *On the Beach at Boulogne*

1869. Oil. $12\frac{5}{8} \times 25\frac{3}{4}$in ($32 \times 65$cm)

Often taken as an example of the weak composition of
Manet's paintings, this beach scene with its admitted
inconsistencies in perspective deserves a more positive
reading. Seemingly casual and open-ended in its
composition, the picture is in fact subtly organized, its
figures on different planes yet related on the surface
through decorative and spontaneous colour. Manet's
witty observation should not be overlooked, particularly
in the group at the far left, which is as amusing as some
of his café profiles or studies of cats.

Pasadena, California, Collection Mr and Mrs Paul Mellon

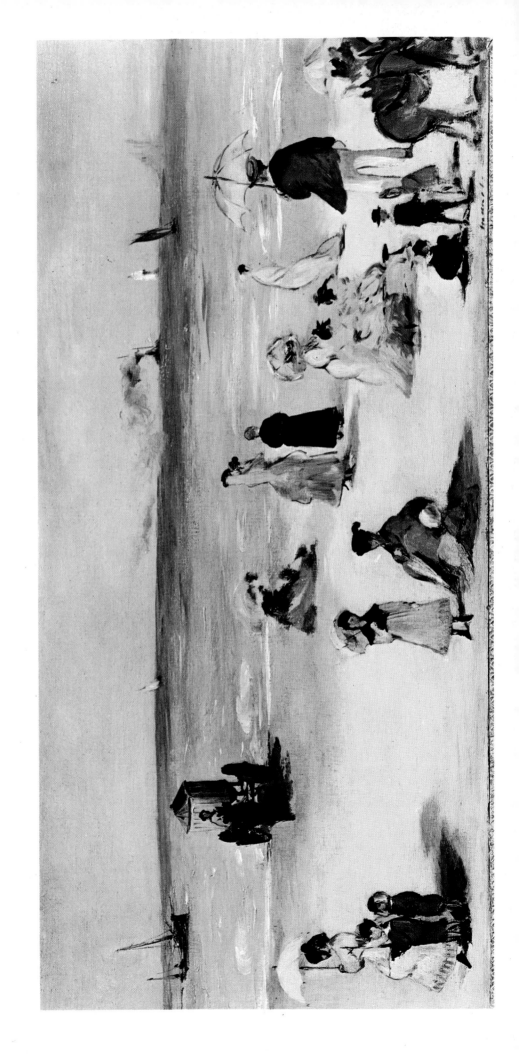

23. *Eva Gonzalès*

1870. Oil. 75 × 51½in (190·5 × 131cm)

The painter Eva Gonzalès (1849–83) was Manet's only
pupil and worked alongside him from 1869, the year
this portrait was begun. Her friendship with Manet
caused some jealousy with Berthe Morisot, never officially
a pupil of his, but a constant visitor to his studio, both as
a model and as an artist. The figure's abstracted gaze,
the grand, simple outline of her dress and the decorative
flower-piece in its elaborate frame give to the painting a
curiously eighteenth-century feeling, a tribute perhaps to
Mme Vigée-Lebrun.

London, National Gallery

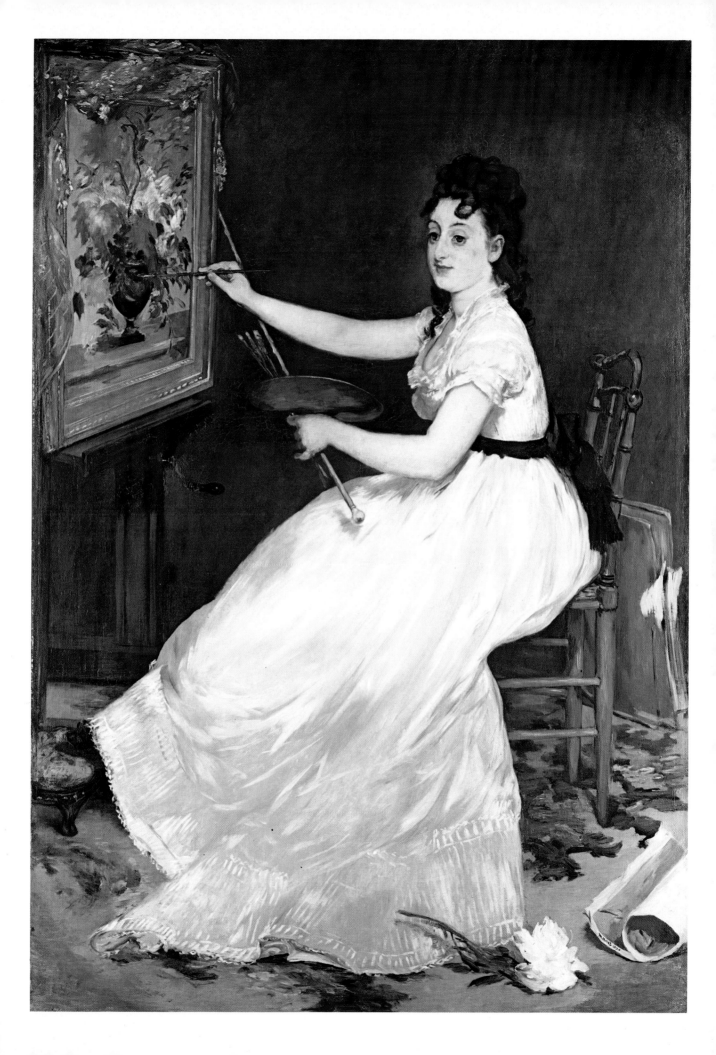

24. *The Railway*

1873. Oil. $36\frac{5}{8} \times 44\frac{1}{2}$in (93 × 113cm)

Victorine Meurend posed for this picture, Manet's last representation of her apart from her appearance as one of the figures in *The Game of Croquet (plate 25)*. The Pont de l'Europe (on the right) was near Manet's studio in the rue St Pétersbourg. The figures were painted in a nearby garden, and the background from sketches made at the Gare St Lazare. The railway frequently appears in the painting and literature of the mid-nineteenth century and even Manet's teacher Thomas Couture, who resented his pupil's marked taste for contemporary urban life, suggested a locomotive as a suitable inspiration for a painting. Manet's treatment of the theme works as a context for his figures, placing and illuminating them, rather than serving as some consciously 'poetic' or picturesque background.

Washington DC, National Gallery of Art

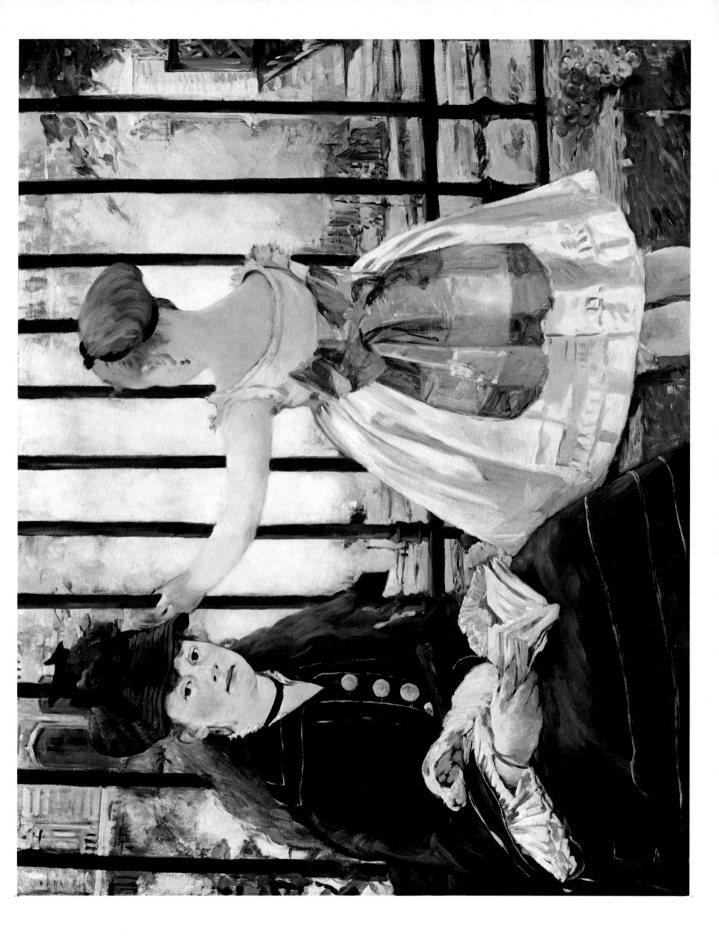

25. *The Game of Croquet*

1873. Oil. $28\frac{1}{2} \times 41\frac{3}{4}$in ($72 \times 106cm$)

Here we have Manet choosing a subject very much part of the Impressionists' world. Monet's *Women in the Garden* comes to mind as well as Berthe Morisot's butterfly hunts or Pissarro's English cricketers. The painting suffers perhaps from a certain indecision in the treatment of light on the grass and foliage (it was painted before Manet had learnt from working with Monet and Renoir at Argenteuil) but the figures are related with the studied casualness noticeable in *On the Beach at Boulogne*. The models were Victorine Meurend, a model, Alice Legouvé, Paul Roudier, a friend of Manet and, seated on the grass, possibly the painter Alfred Stevens in whose garden in Paris the game took place.

Frankfurt, Städelsches Kunstinstitut

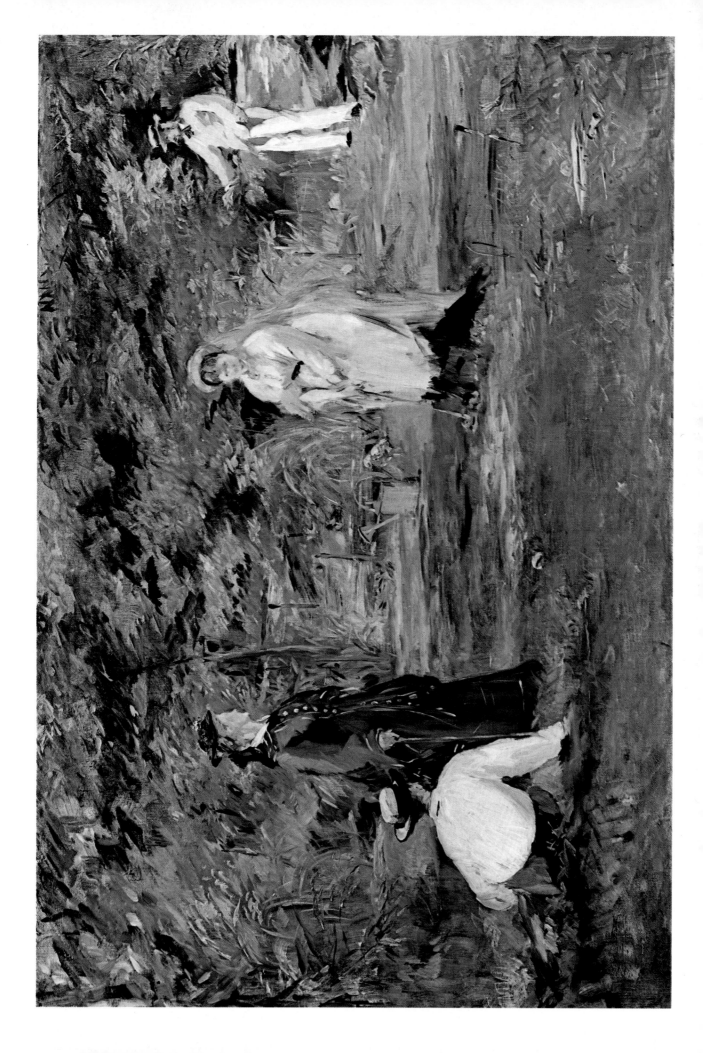

26. *The Seine at Argenteuil*

1874. Oil. 24 × 39⅜ in (61 × 100cm)

Manet made two studies of these moored boats in August
1874 (a darker version without figures is in the National
Museum of Wales). Manet had helped Monet to secure
a house at Argenteuil across the river from his own
property at Gennevilliers, then about twenty minutes by
train from Paris; Renoir joined them and paintings by
the three artists were often executed from similar view
points. Manet's work is here less vivacious in its
handling than theirs. The foreground is relatively
restrained, having none of those touches of pure colour
which we find in Monet's work. The contemplative
woman and her child (it has been suggested that Mme
Monet and her son Jean were the models) are
reminiscent of Seurat's sketches of figures by the Seine
made a decade later.

London, National Gallery

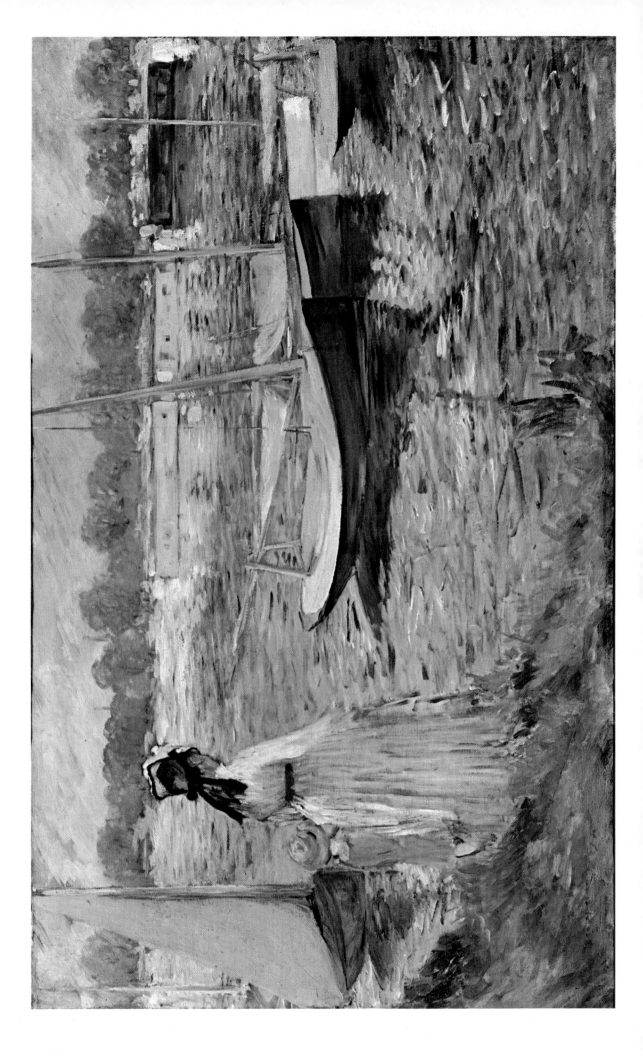

27. *Claude Monet in his Floating Studio*

1874. Oil. $31\frac{1}{2} \times 38\frac{1}{2}$in (80 × 98cm)

The Manet family owned a house at Gennevilliers across the Seine from Argenteuil where Monet had a house and in 1874 the painters saw much of each other. They were sometimes joined by Renoir when working out of doors. It was the first time Manet painted entirely away from the studio. The picture is worked with breadth and freedom over the whole canvas yet structured by verticals and horizontals with Manet's customary strength. Monet's floating studio enabled him to observe light on water at close quarters and gain new vantage-points and perspectives impossible on land. In this he followed the example of Daubigny whose studio boat Monet had seen.

Munich, Alte Pinakothek

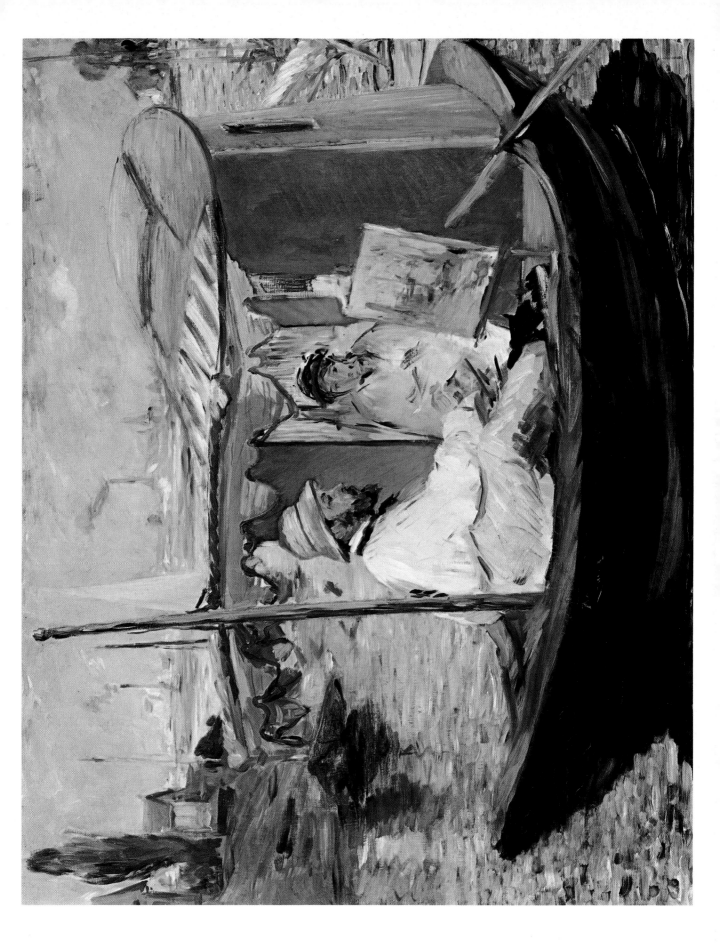

28. *Boating*

1874. Oil. $37\frac{3}{4} \times 51\frac{1}{8}$in (96 × 130cm)

Seen from above, the water filling the whole background, the sail cut abruptly, this work instantly evokes the 'floating world' of the Japanese print. Yet there is none of the Japonaiserie of Whistler, for example; Manet's couple might come straight from a contemporary, realist novel (the man who posed for Manet is thought to have been the sportsman Baron Barbier, a friend of Maupassant; Manet's brother-in-law has also been suggested as the model). The picture's theme is quintessentially Impressionist; boats and sailing are frequent motifs in Monet, Renoir, Sisley. Later, Caillebotte and Signac both owned several boats and ferried Seurat to the Ile de la Grande Jatte. But Manet's vision remains distinct from Monet and Renoir in that reflected colour plays little part in his conception.

New York, Metropolitan Museum

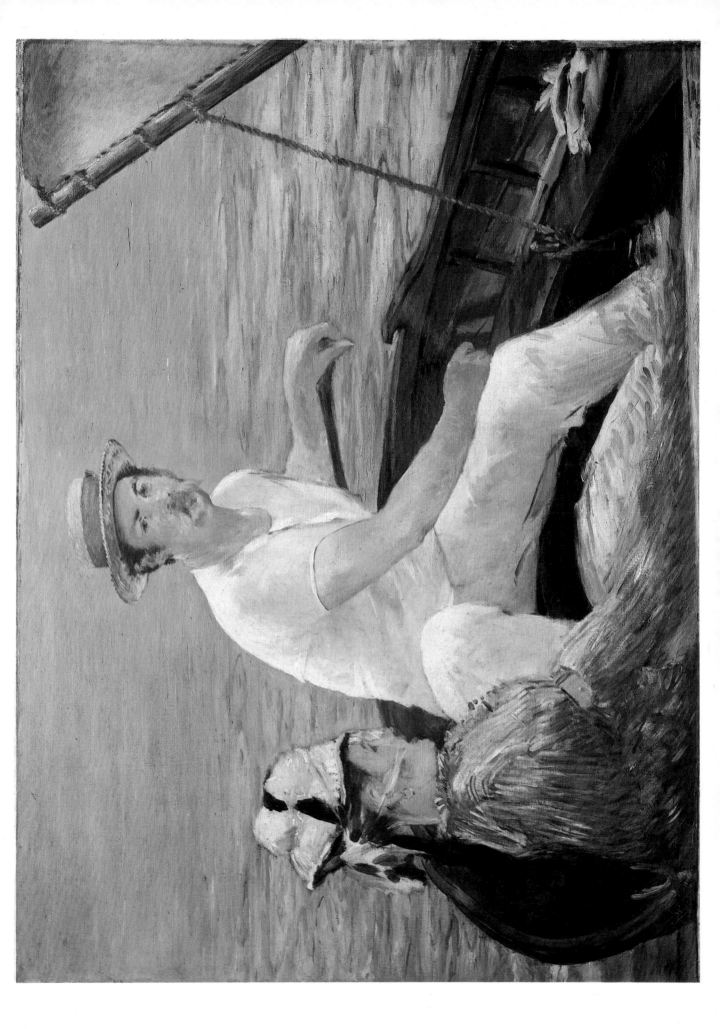

29. *Argenteuil*

1874. Oil. $58\frac{5}{8} \times 51\frac{1}{2}$in (149 × 131cm)

The roofs and church spire of Argenteuil appear along the river bank as they do in countless Impressionist works of the 1870s. Manet evokes the pleasurable relaxations of a summer Sunday on the Seine — sunlight, boating, the woman's wild flowers, light striped clothes, the possibility of a little afternoon flirtation. Anecdotal overtones are removed however by the steady gaze of the young woman. The overall warm tonality is checked here and there by darker accents and the cool white gauze on the fashionable black straw hat. Manet comes close to Renoir in the picture's uncomplicated sensuality.

Tournai, Musée des Beaux-Arts

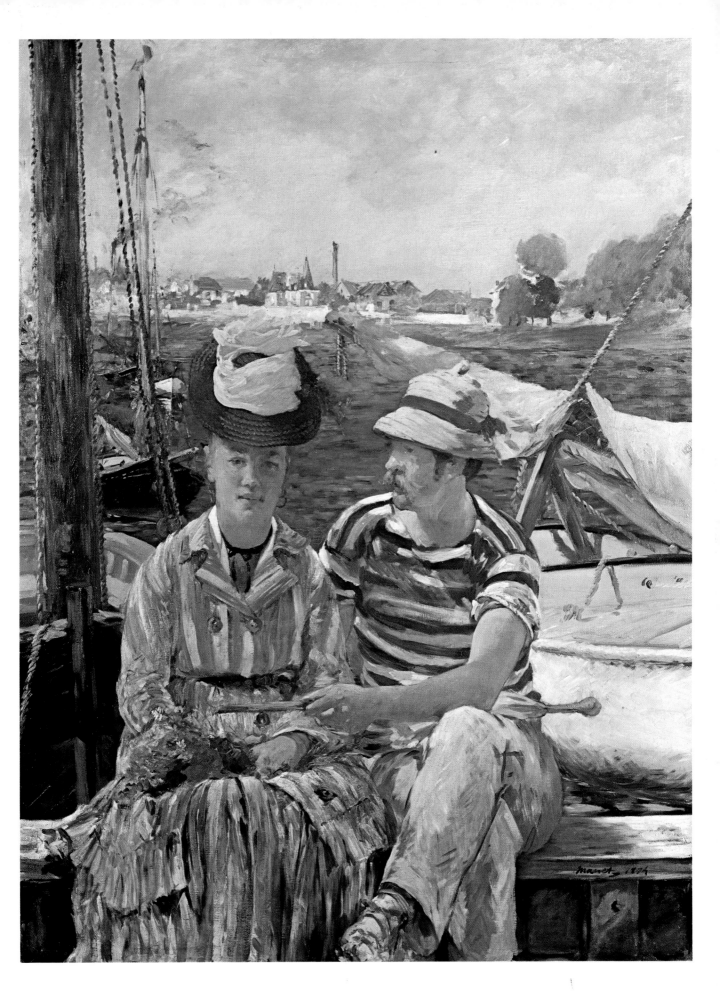

30. *Portrait of Stéphane Mallarmé*

1876. Oil. $10\frac{5}{8} \times 13\frac{3}{4}in$ ($27 \times 35cm$)

The great French poet Mallarmé (1842–98) was among
Manet's closest friends and they saw each other
constantly, as neighbours in Paris, until Manet's death.
In 1885 Mallarmé wrote to Verlaine: 'J'ai dix ans vu
tous les jours Manet, dont l'absence aujourd'hui me
parait invraisemblable' ('I saw Manet every day for ten
years, and now it's inconceivable that he's not here').
One of Mallarmé's great pleasures was to smoke a cigar
and talk to Manet, their conversation ranging over every
variety of subject. In 1876 Manet made illustrations for
the poet's translations of Poe and provided four
drawings for Mallarmé's poem *L'Après-midi d'un faune*.
This portrait was completed in one sitting.

Paris, Louvre

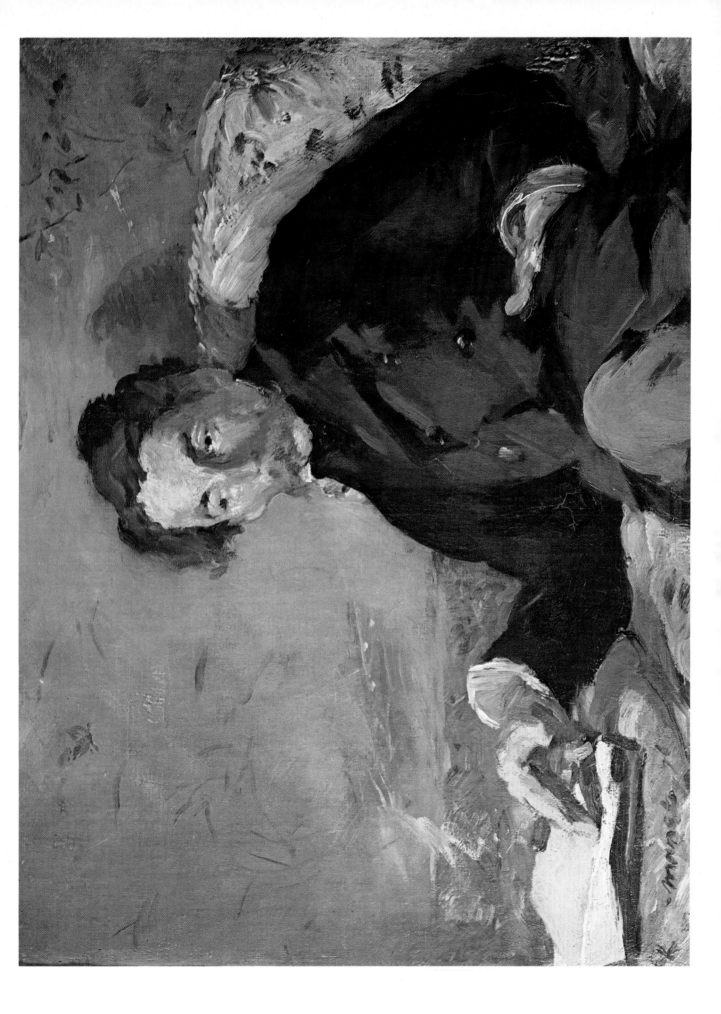

31. *The Road-Menders in the rue de Berne*

1878. Oil. 25 × 31½in (63·5 × 80cm)

The rue de Berne, formerly the rue Mosnier, could be seen from Manet's studio; from his window he drew the passers-by and painted the street decked with flags in 1878. This is one of Manet's finest Impressionist pictures: sunlit, airy, the shadows blue and violet, the whole bathed in a warm grey-pink light; the scene, briskly and affectionately painted, is highly expressive of Manet's urban sensibility.

London, Private Collection

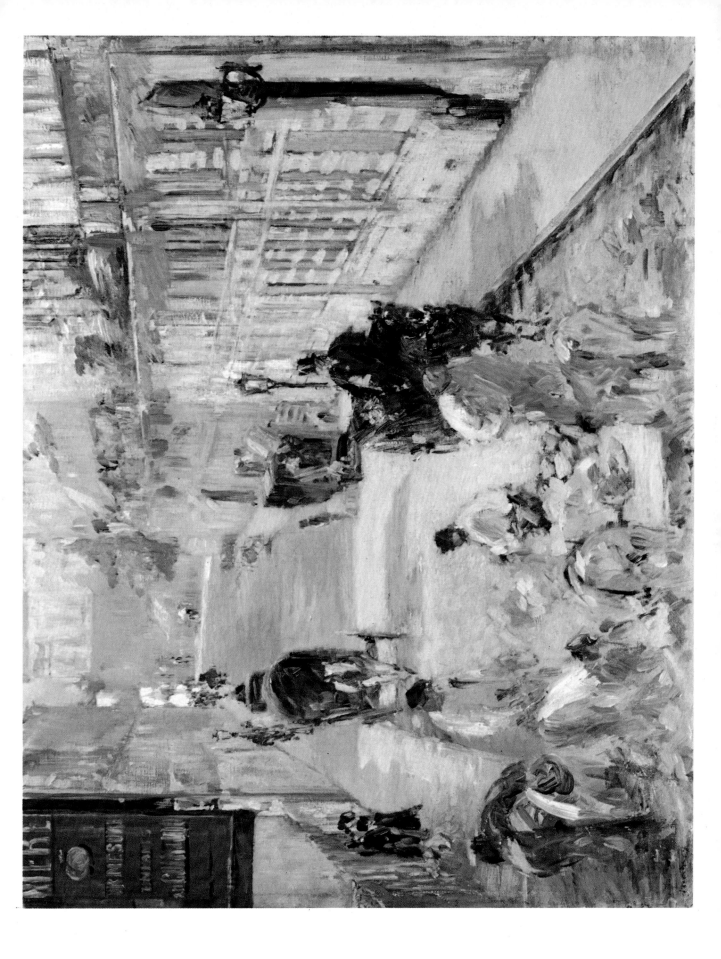

32. *Nana*

1877. Oil. 59 × 45⅝in (150 × 116cm)

One of Manet's most celebrated evocations of Parisian life, *Nana* caused crowds to gather and police to intervene when it was exhibited in a shop window in the Boulevard des Capucines, having been turned down by the Salon jury. Zola's novel *Nana* on the rise and fall of a great courtesan was being serialized at the time the picture was painted. Nana is seen here in the corner of her boudoir as she dresses, the activities of her toilette emphasized at the expense of her incompletely seen admirer, straightbacked in his evening clothes. As one critic has written: '. . . it is Manet's discretion, his laconic refusal either to poeticize or to vulgarize his piquant themes that accounts for their vivid contemporaneity'.

Hamburg, Kunsthalle

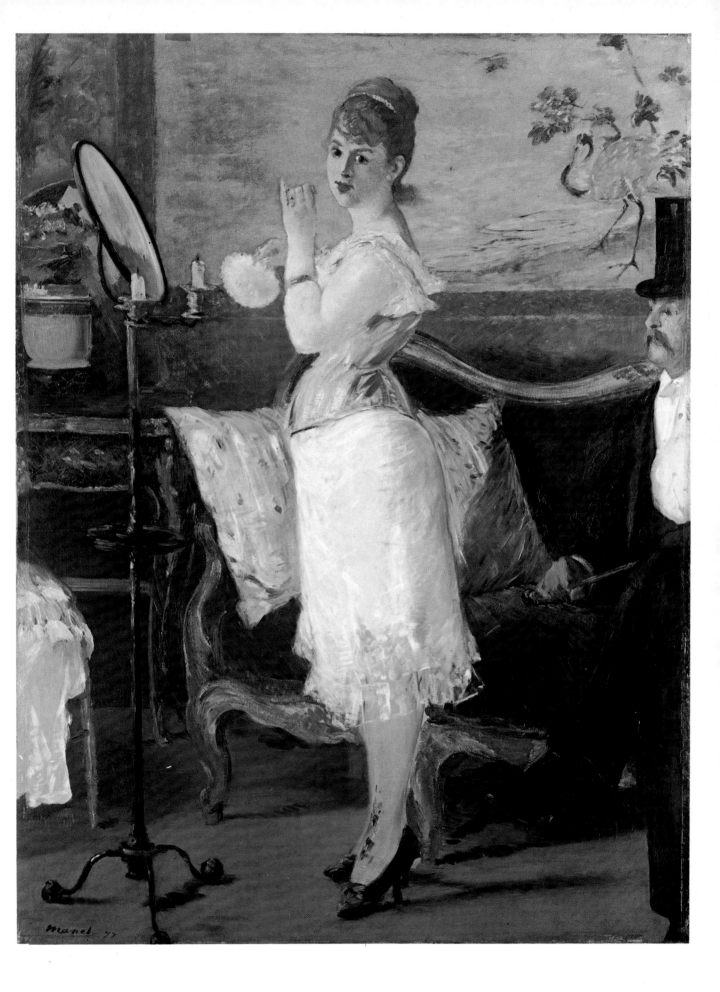

33. *Skating*

1877. Oil. 36$\frac{3}{8}$ × 28$\frac{3}{8}$in (93 × 72·5cm)

The increasing freedom of Manet's brushwork and new methods of composition coincided with a desire to paint a whole series of works depicting life in contemporary Paris — its bars and cafés in particular. Women are usually the central figures of these compositions; here we see Henriette Hauser, who also posed for *Nana*, at a well-known skating rink in the rue Blanche. She turns momentarily to look in our direction with that self-absorbed regard we find so often in Manet's paintings.

New York, Collection Mrs Maurice Wertheim

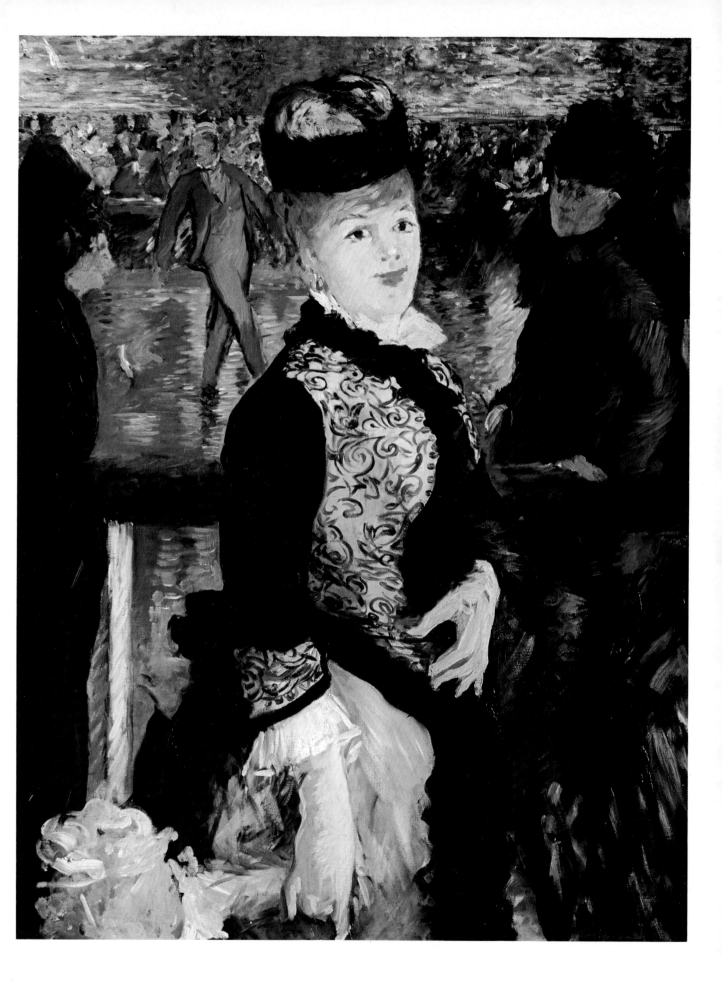

34. *At Père Lathuille's*

1879. Oil. $36\frac{3}{8} \times 44\frac{1}{8}$ in (93 × 112cm)

'Père Lathuille' was a restaurant near the Café Guerbois, in the avenue de Clichy, frequented by Manet. The son of the proprietor, Louis Gauthier-Lathuille, posed for the painting in the restaurant garden during the mornings. Initially a pretty young actress, Ellen Andrée, posed for Manet but proved unreliable. The older woman seen here with her amusing profile and pert hat was a Mlle Fresnels, a relation of the composer Offenbach. This was one of the last of Manet's large compositions evoking contemporary Parisian life and was received with some success at the Salon of 1879.

Tournai, Musée des Beaux-Arts

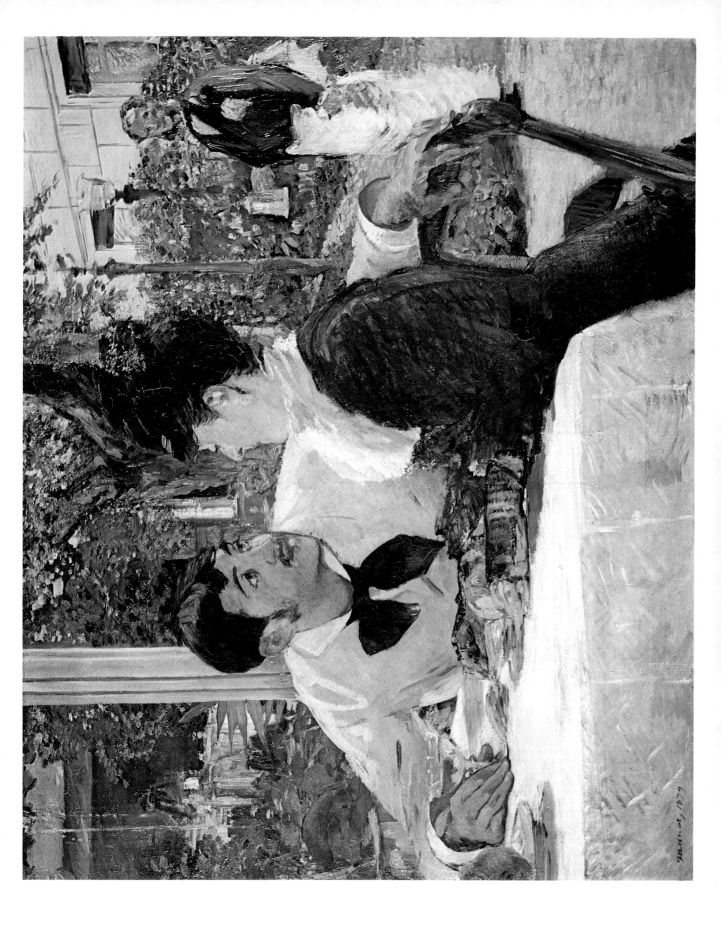

35. *At the Café*

1878. Oil. $18\frac{5}{8} \times 15\frac{3}{8}$in (47 × 39cm)

In his pamphlet on Manet, published in 1867, Zola
wrote of the painter's love of society, his polished
manners and appearance, and the pleasure he found 'in
the perfumed and glittering refinement' of fashionable
evening parties. He had painted the Tuileries, a ballroom,
and race-courses in the 1860s. In the following decade
came a series of pictures of city life, several of which
show the cafés and bars he visited with his friends. The
comparative novelty of Manet's subject-matter is
perfectly fused with the inventiveness of his method, its
changes of focus and spatial conciseness.

Baltimore, Walters Art Gallery

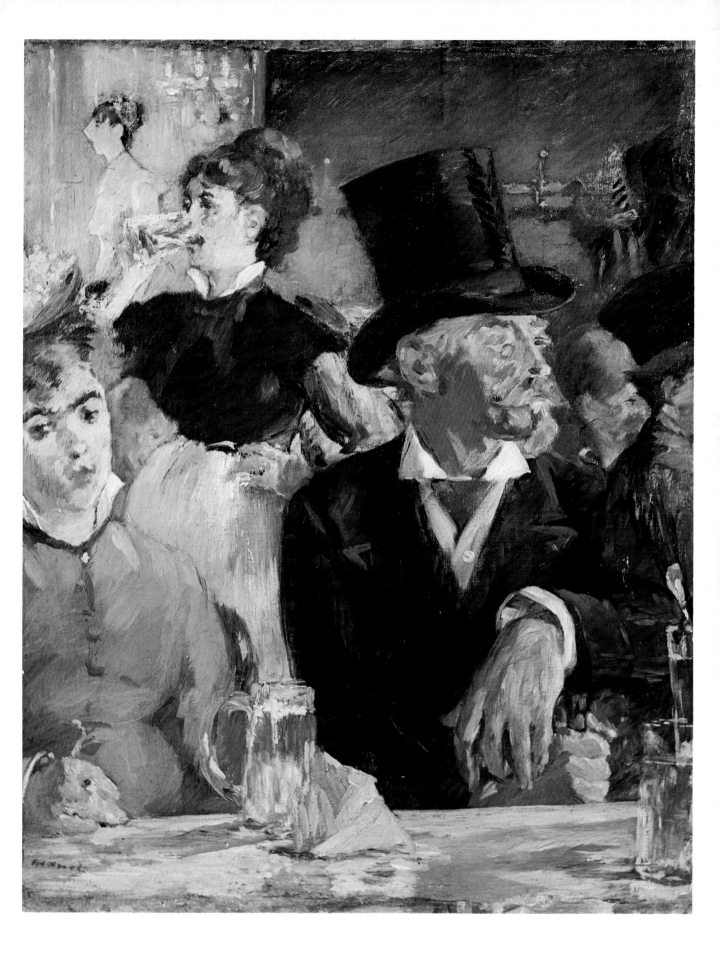

36. *The Waitress*

1878. Oil. $30\frac{1}{4} \times 24\frac{1}{4}$in (77 × 61·5cm)

There are two versions of this painting; the other, in the National Gallery, London, is larger and more crowded with clients as a cabaret proceeds on stage. The waitress who posed for Manet insisted she be accompanied by her young man who appears here as absorbed in the cabaret as the waitress seems to be with herself — inviting comparison with the serving-woman in *Luncheon in the Studio (plate 19)*. The lively immediacy of this and similar paintings is heightened by figures cut at the edge of the picture, heads and profiles interrupted or partially seen against other figures and by there being no one stable source of light.

Paris, Louvre

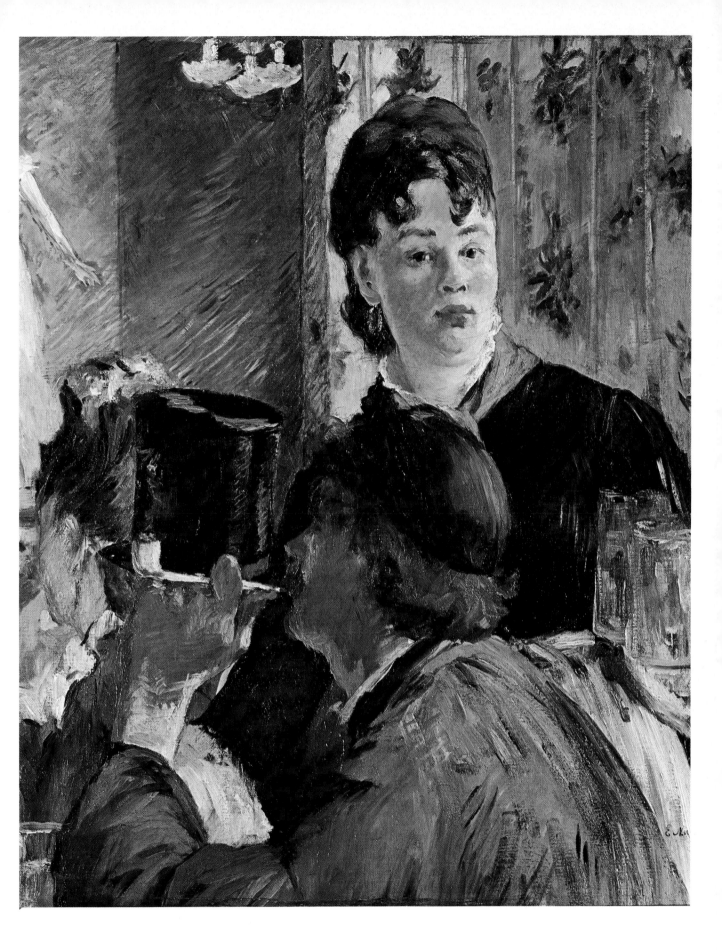

37. *Interior of a Café*

c.1880. Pastel. $12\frac{3}{4} \times 18in$ ($32 \cdot 5 \times 45cm$)

In 1879 Manet first felt the effects of the illness which resulted in his premature death four years later. He found pastel and watercolour easier to use than the more demanding medium of oil paint, although he made one last great oil painting, finished with difficulty, *A Bar at the Folies-Bergère (plate 38)*. This witty pastel belongs to that period, and is remarkable for its suggestion of extensive space, unlike the compressed compositions of *The Waitress (plate 36)* or *At the Café (plate 35)*. The 'jolie-laide' with her drink before her is reminiscent of figures in Degas's pastels of similar café interiors and bars.

Glasgow, City Art Gallery

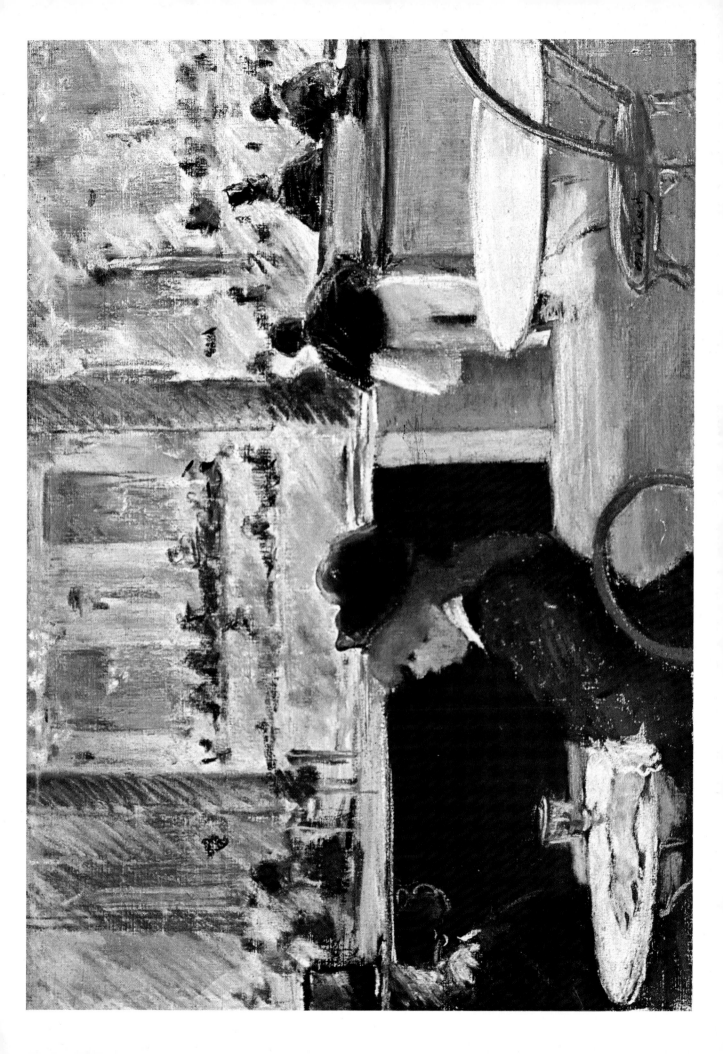

38. *A Bar at the Folies-Bergère*

1881–2. Oil. $37\frac{3}{4} \times 51\frac{1}{8}$in (96 × 130cm)

This was Manet's final, great achievement received at the 1882 Salon with critical acclaim. The marble bar was reconstructed in his studio, his model Suzon posing behind it; the rest was painted from sketches made at the Folies-Bergère (opened in 1869). Features found throughout Manet's work are brought together in a haunting, magnificent composition — the dazzling still life painted with accurate virtuosity; the single, isolated figure staring towards us, bored (with her job, with posing, with the attentions of the man at the bar — the whole picture is rich with possibilities of interpretation); the crowds (which include some of Manet's friends) shimmering in the mirror behind the bar; the picture's ambiguous spatial scheme (some commentators deny that it is a mirror); the humorous detail of an acrobat's green shoes in the top left corner. Such observations and ambiguities ensure the continuing power of Manet's imagery.

London, Courtauld Institute Galleries

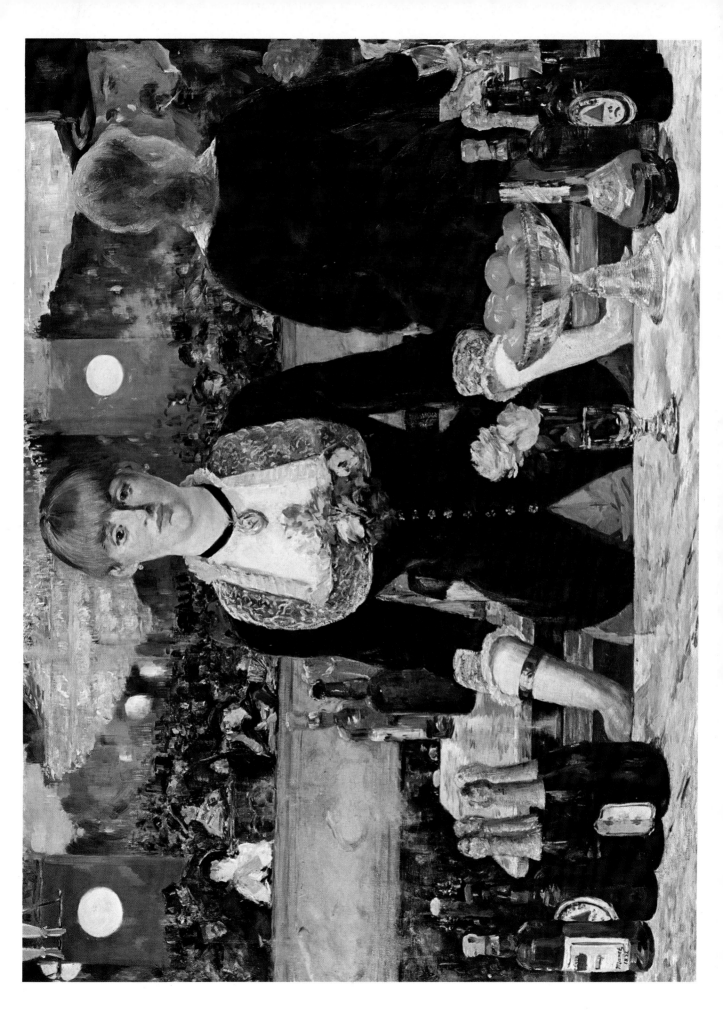

39. *House at Rueil*

1882. Oil. $36\frac{1}{4} \times 28\frac{1}{2}$in ($92 \times 72 \cdot 5cm$)

In spite of his increasing debility (he walked with a cane and was compelled to remain seated most of the time) Manet continued to work, and in the last summer of his life made several airy, delicious paintings of the house and garden he had rented at Rueil near Malmaison outside Paris. This one is, perhaps, the best of six paintings done there. Although he does not use the broken, complementary colours of Monet or Renoir, the effect of bright light and cool shadow is assured by his sensitivity to subtle tonal changes, seen here particularly on the façade of the house.

Berlin, Staatliche Museen

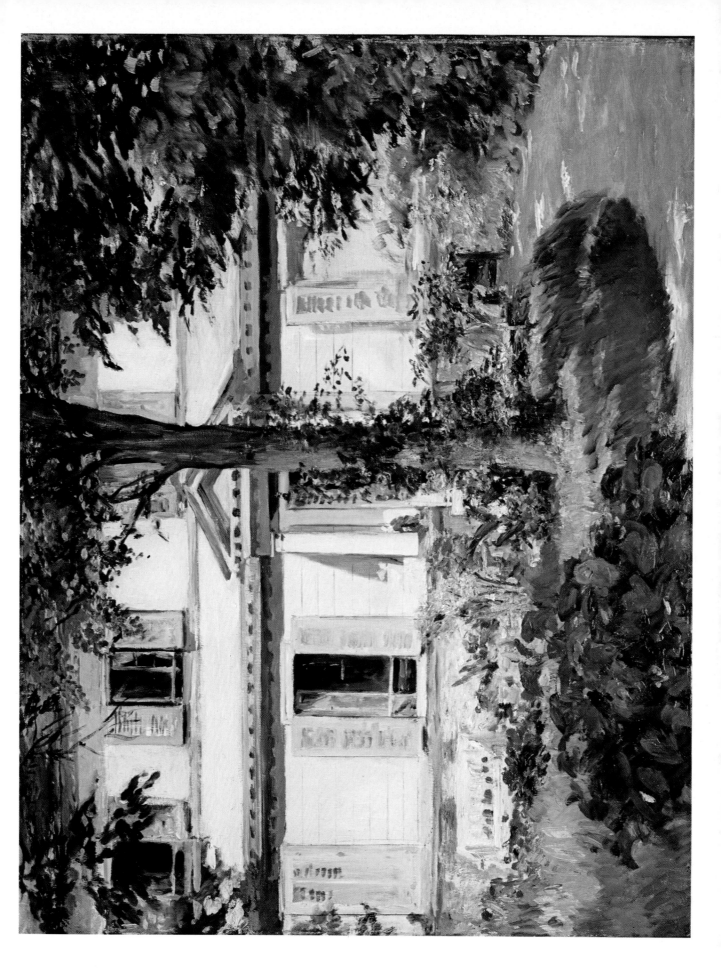

40. *Autumn (Méry Laurent)*

1881. Oil. 28¾ × 20⅛in (73 × 51cm)

Innumerable beautiful and often talented women posed for Manet in the last years of his life, at his studio in Paris or at the country houses he took during the summers. Usually their portraits were executed in pastel but this one belongs to a series Manet contemplated (but which remained incomplete) of the four seasons — oil paintings of four characteristically dressed women. The actress and courtesan Méry Laurent sat frequently for Manet and was the friend of several painters and writers including Mallarmé and George Moore who wrote of her as 'the daughter of a peasant and the mistress of all the great men of that time'.

Nancy, Musée des Beaux-Arts

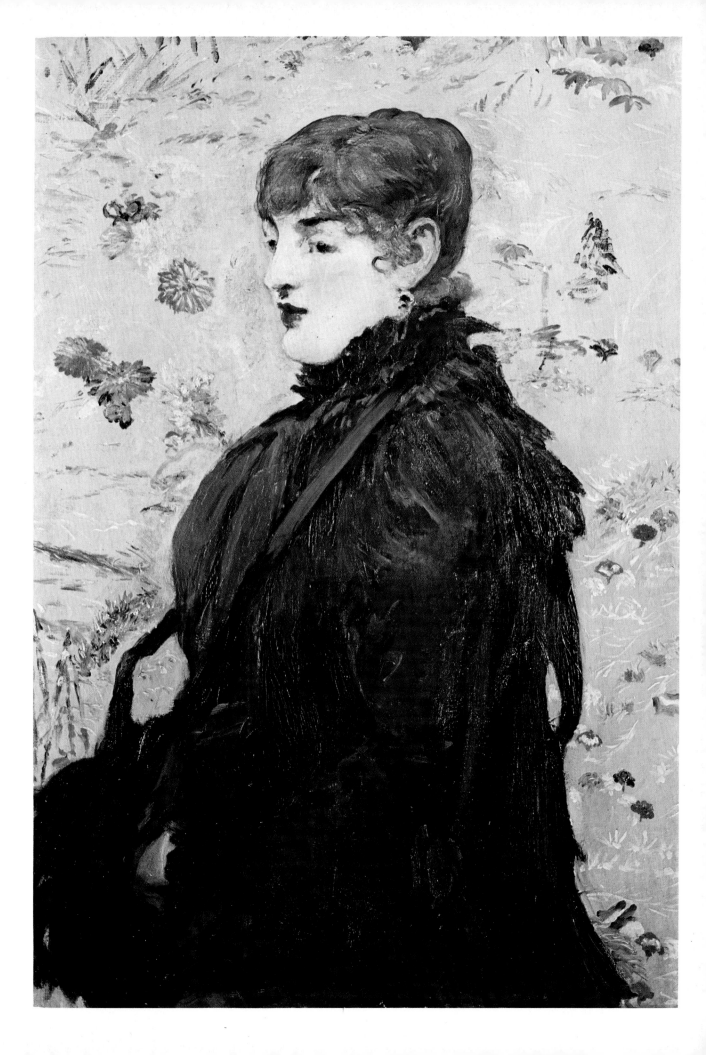

Acknowledgements, and list of illustrations and sources

THE AUTHOR AND BLACKER CALMANN COOPER LTD would like to thank the museums and owners who allowed works in their collections to be reproduced in this book. Unless otherwise stated they provided the transparencies used. The author and Blacker Calmann Cooper Ltd would also like to thank the photographers and photographic agencies who provided transparencies.